Fantasy Art Drawing:

Learn How to Draw Various Fantasy Creatures with Step by Step Guide

By Nick Laskey

Copyright©2016 by Nick Laskey
All Rights Reserved

Copyright © 2016 by Nick Laskey

All rights reserved. No part of this publication may be reproduced, distributed, or transmitted in any form or by any means, including photocopying, recording, or other electronic or mechanical methods, without the prior written permission of the author, except in the case of brief quotations embodied in critical reviews and certain other noncommercial uses permitted by copyright law.

Table of Contents

Introduction **5**
Chapter 1 – Warrior Lord **6**
Chapter 2 – Warrior Lady **26**
Chapter 3 – Unicorn **39**
Chapter 4 – Pegasus **50**
Chapter 5 – Witch **63**
Chapter 6 – Dragon **78**
Conclusion **90**

Disclaimer

While all attempts have been made to verify the information provided in this book, the author does assume any responsibility for errors, omissions, or contrary interpretations of the subject matter contained within. The information provided in this book is for educational and entertainment purposes only. The reader is responsible for his or her own actions and the author does not accept any responsibilities for any liabilities or damages, real or perceived, resulting from the use of this information.

The trademarks that are used are without any consent, and the publication of the trademark is without permission or backing by the trademark owner. All trademarks and brands within this book are for clarifying purposes only and are the owned by the owners themselves, not affiliated with this document.

Introduction

Drawing can be a relaxing and rewarding pastime. All artists start from the basics and work up to creating their own pieces, building up their portfolios and working to improve their skills.

Fantasy art can be especially rewarding. Fantasy artists can go on to creating comics, illustrating books, working on tabletop games (such as *Dungeons and Dragons*), and even working to create settings and characters for video games. Fantasy art has been around for centuries, featuring drawings of monsters and mythical heroes.

Today, fantasy art can be found all around us. Unicorns can be found in children's shows, while heroes can be found in video games and movies. Beautiful fantasy art can be found in games such as *Dungeons and Dragons* or *Pathfinder*. Creating your own fantasy art is incredibly fun. This book is a step-by-step guide to drawing your own fantasy creatures and people. In this book, you'll learn how to draw a Warrior Lord, a Warrior Lady, a unicorn, a Pegasus, a witch, and, of course, a dragon (what kind of fantasy book doesn't have a dragon, after all).

Tools you'll need include paper and pencil, preferably a drawing pencil instead of a mechanical pencil. So sit back, get ready to draw, and enjoy creating a fantastic world!

Chapter 1 – Warrior Lord

One of the most important fantasy characters, the Warrior Lord is sometimes the hero and sometimes the villain. Either way, he needs to be striking and handsome, with a powerful, imposing figure. What we want to radiate is power here, to make sure that the viewer knows who is in charge, who wields the weapon, and who is going to win the war.

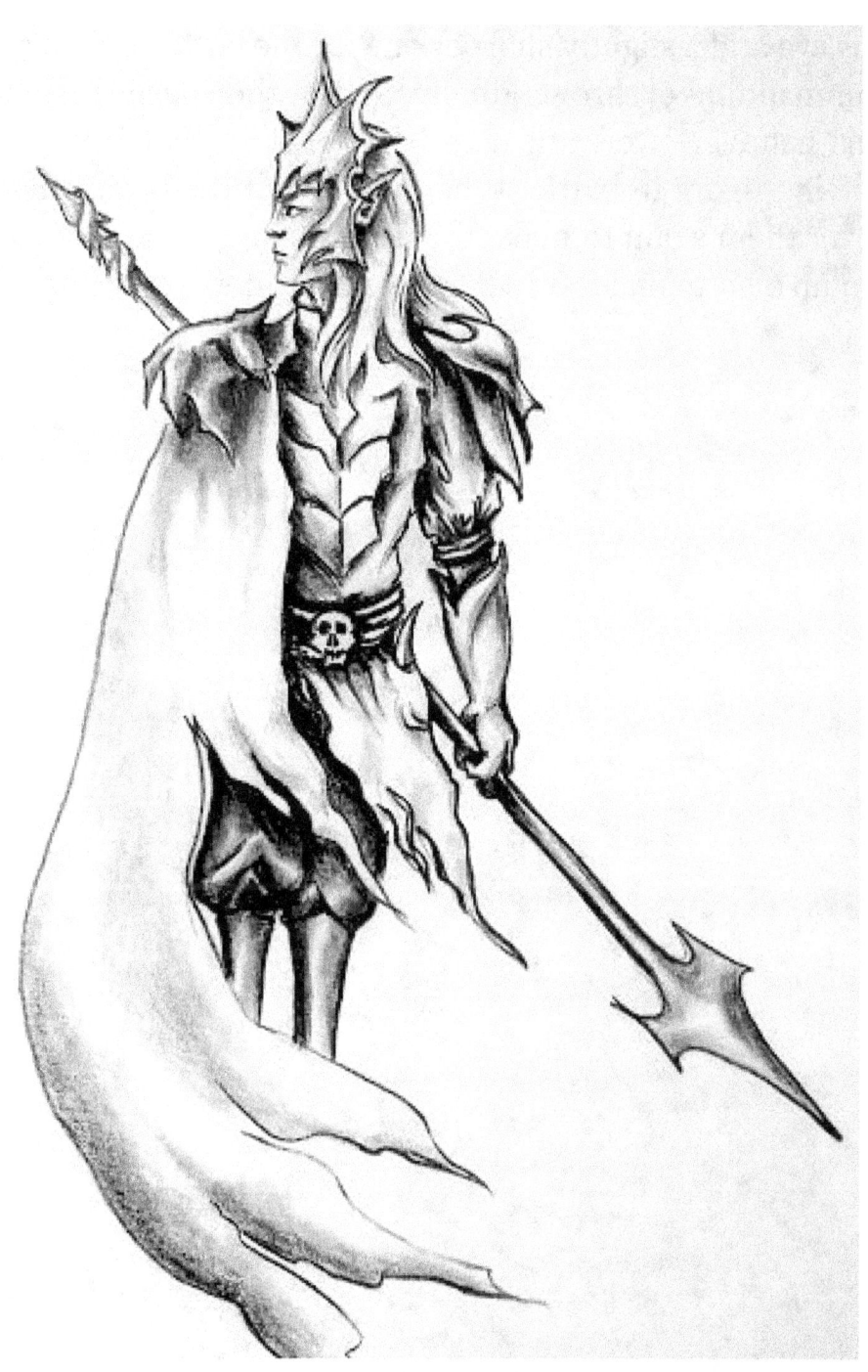

The first thing we're going to start out with is his face. Draw out the lines of his nose, lips, and chin, using light strokes so that they'll be easy to erase if necessary. Make a curved line for the top

of his eye and a slightly sharper one for the bottom, then give him a commanding eyebrow. Finally, add in the sharp, pointed lines of his helmet – we want it to be jagged, so that it will strike a terrifying figure in battle. When you've got the basic lines down, go over them again to make them stand out a little more, smooth them up a bit to make sure they're exactly how you want them.

Next we're going to create his ear, the sweeping lines of his hair, and the outline of his shoulder guards.

To make the ear, we're going to do first a sweeping line on the top, then a line that dips for the bottom, connecting the two lines to make a point. For the inside of the ear, we're going to make something like a pointy 'S' shape, the curve of the outside of the ear and the curve of the inside of the ear. For the hair, use light strokes – this is just the outline, we'll fill more detail in here later.

In order to place the shoulder armor, we have to fill in the line of the neck and the top of the shirt. Draw the left shoulder armor so that it curves over where the shoulder would be, and the right in the same way, this time dropping down a little bit to lightly fill in the line of the arm, just to make sure that you have everything placed in the right way.

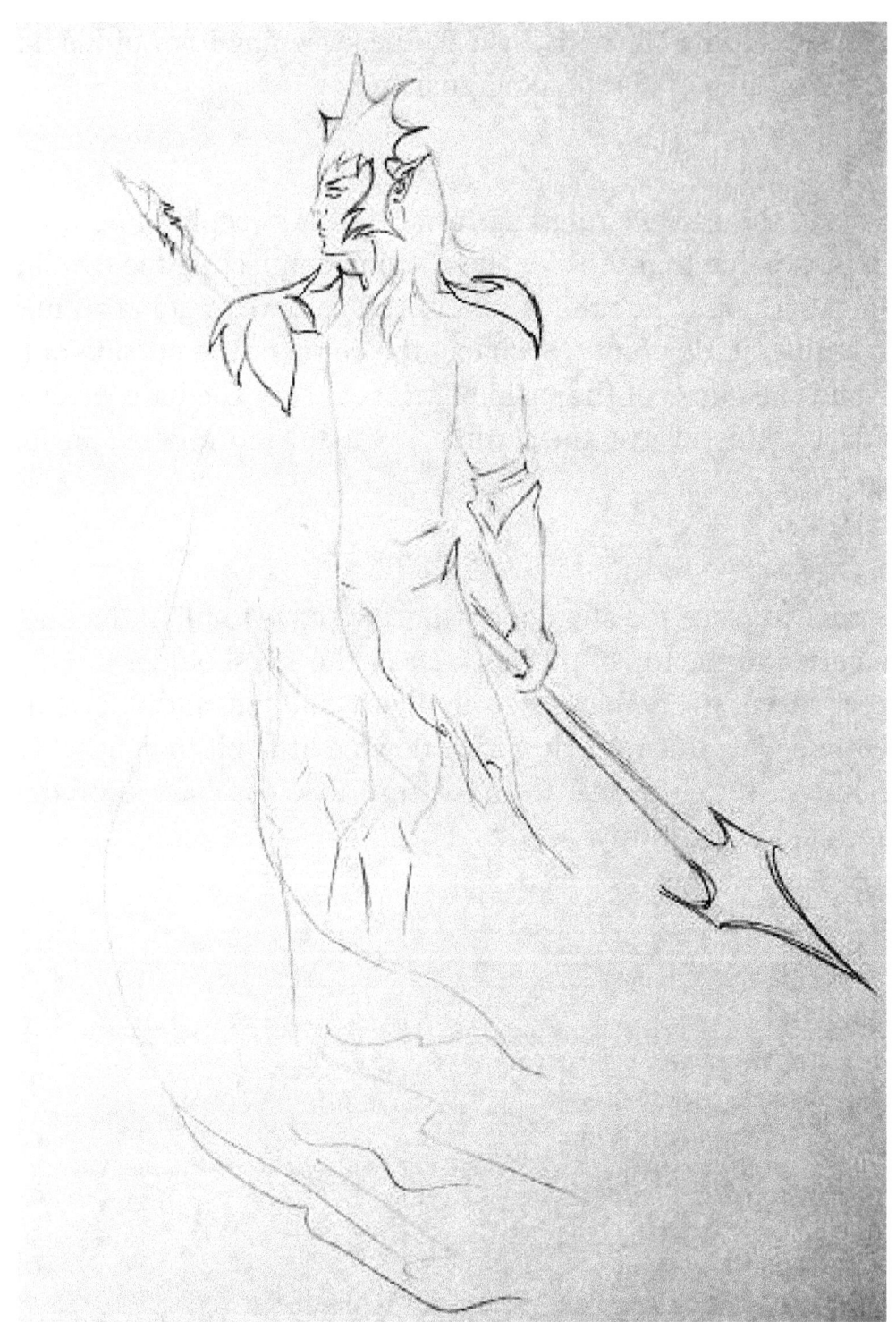

Next, we're going to work on creating the outline of the rest of the body and the weapon. Lightly draw the cape sweeping over and around the Warrior Lord, making sure that you can easily erase if you need to. Lightly draw the line of the chest in, as well as the rest of the arm and the hip sash. Finally, add the lines of the legs with light gestures – don't worry, we'll fill all of this in later.

Last but not least, draw the end of the staff and the front of the staff, making sure to keep the lines on the same plane – we don't want the staff to look like it's jutting out of his back, we want to look like he's holding half of it behind him.

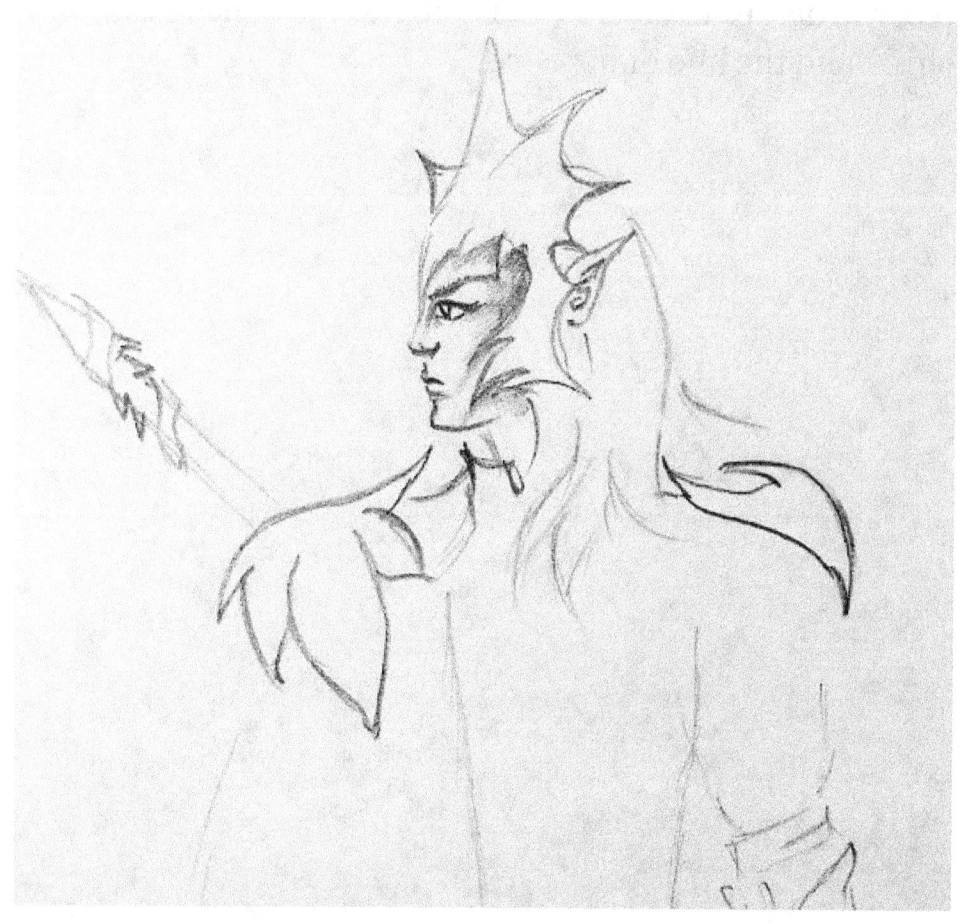

We're going to start thickening our lines and doing some shading. Make sure that the lines are thick and bold – these are the lines that we want to stand out, these are the outlines that hold the rest of our gestures.

As for shading, imagine that there's a light source in the top left corner – like a big sun or a big lamp. All of our shading should come from this light source, so we're going to add a little shade on the face below the helmet and on the lower lip. Also, take this chance to fill in the eye and the eyebrow, giving him an expression of intent. Remember, the farther away from the light source, the darker the shadow is going to be – shade the curve of his cheek and the line of his nose.

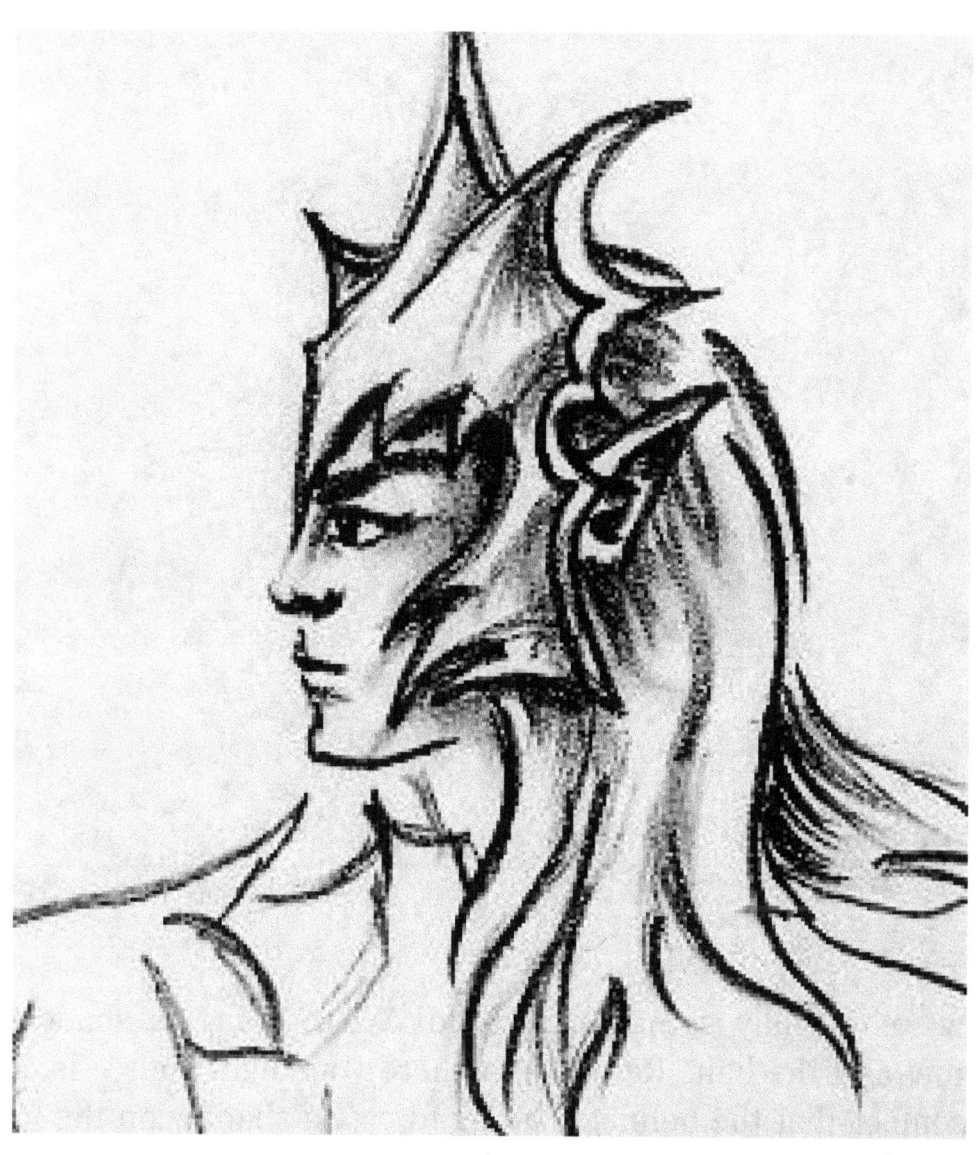

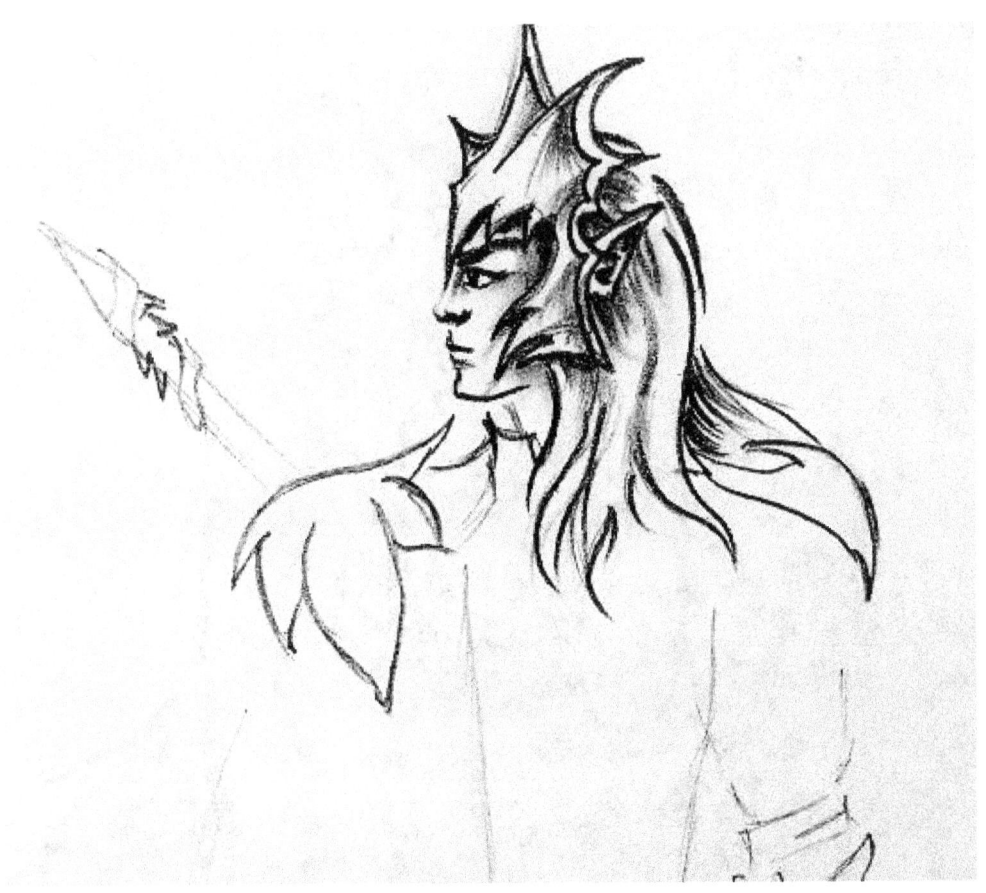

Now we're really going to get bold! We're going to shade the helmet and the hair. Remember where your light source is, and remember that the helmet is going to cast a shadow on the hair. So the top of the hair is going to be darker than the bottom of the hair – the bottom of the hair is really just going to be the shadows that stand out, or the ones that create the lines. Take this opportunity to add a little more hair falling over his shoulder, and shade that as well.

Whatever you do, don't shade in one block – don't create a shape and then fill it in. This is hair, so the shade comes from the strands themselves, meaning that we want to use lines. You can

go over the same line over and over to get that perfect shade, and don't be afraid of your eraser.

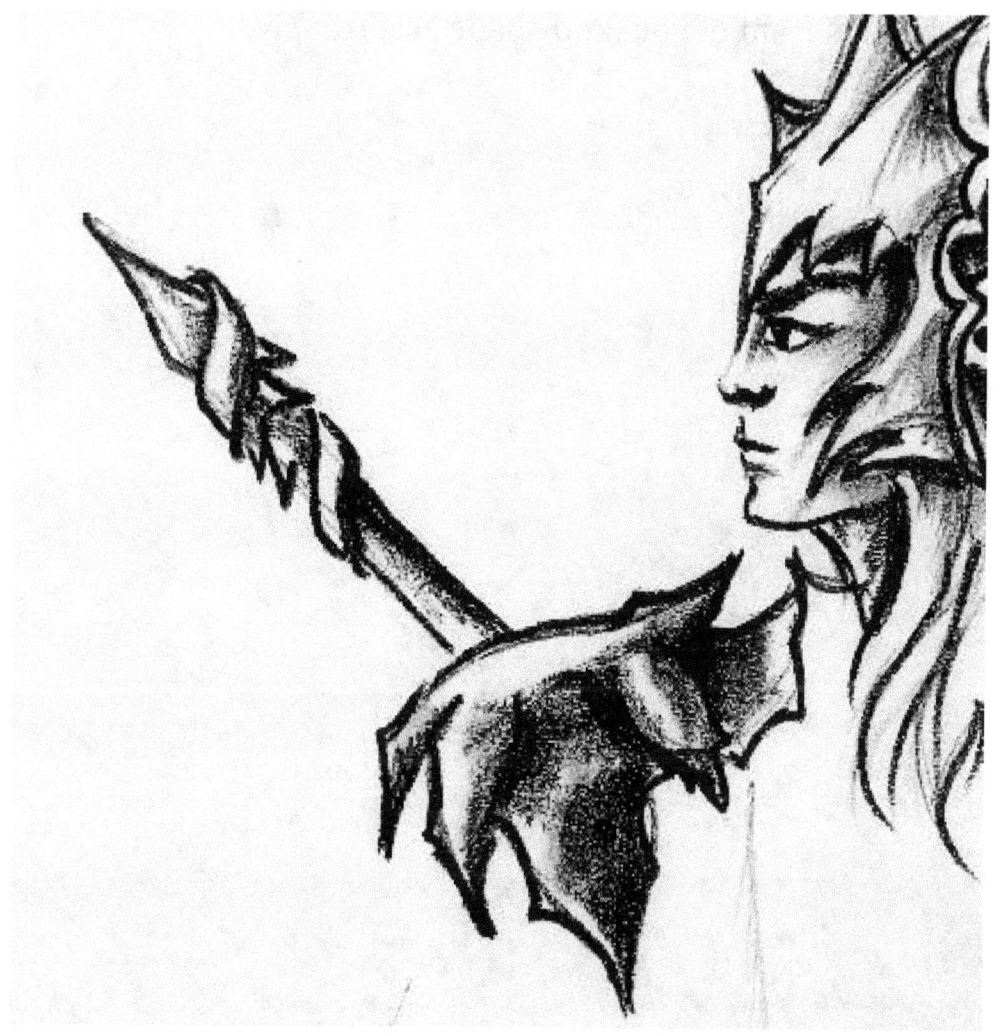

Next up is the top of the staff and the shoulder armor. Now, when it comes to shading the staff, follow the lines as shown – the light source will cast onto it while the decorations also cast shadow. Bolden the lines, that will add a little bit of shade as well, along with a finality to the lines.

As for the shoulder armor, this is a metal piece so the shading is going to be dramatic. This isn't hair, so feel free to make shapes and fill them in – just make sure that the consistency is steady. Think about the way that the shape of the armor curves, imagine it in space in front of you, and shade accordingly.

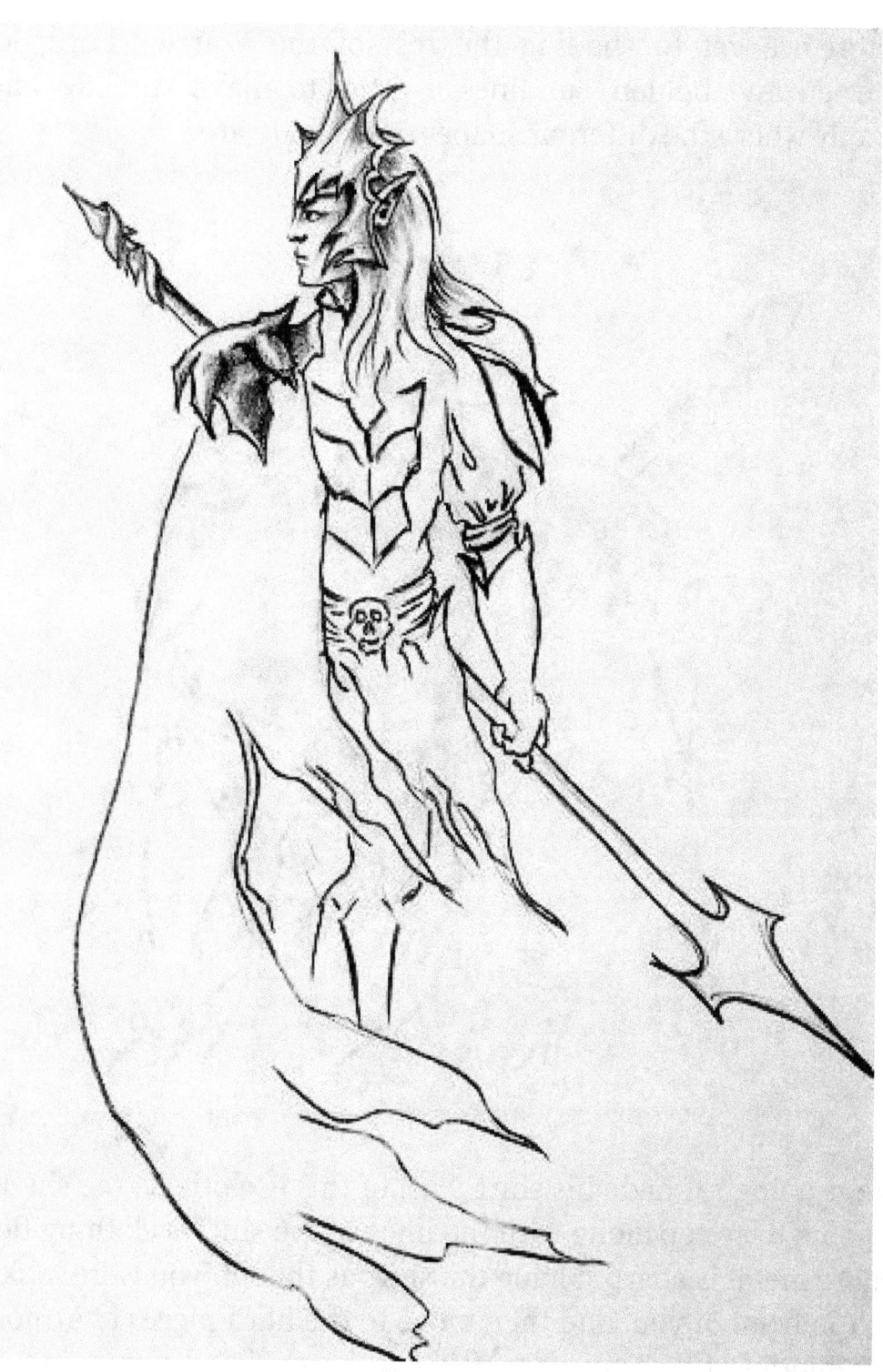

Before we get to shading the rest of the Warrior Lord, let's sharpen and bolden our lines a little, to make sure we know exactly where the different shapes of his body are.

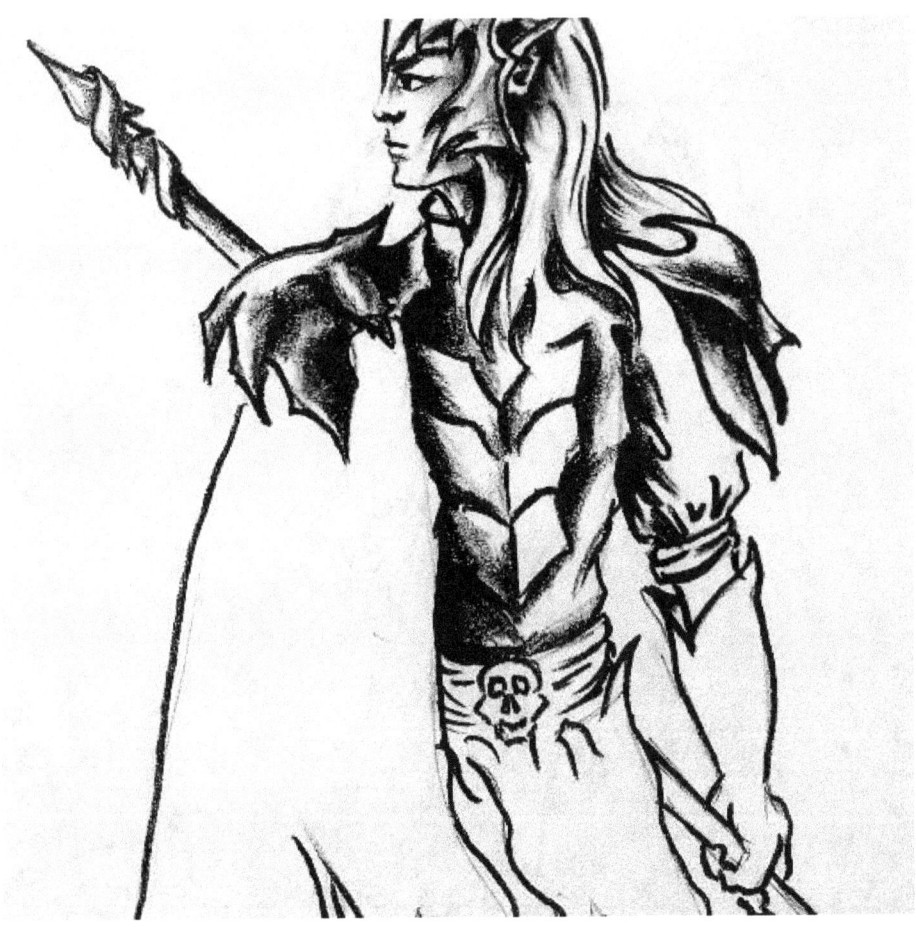

We're going to shade his shirt. Part of this is cloth, so the shading is going to sweep along with the lines of the shirt – clothing flows where metal is sharp. Shade the shirt as though you were looking at it in front of you, and then move to the hard pieces of armor in the middle of it. These are going to be stiff and unmoving, not flowing like the shirt is. The cape is going to cast a shadow over the entire side.

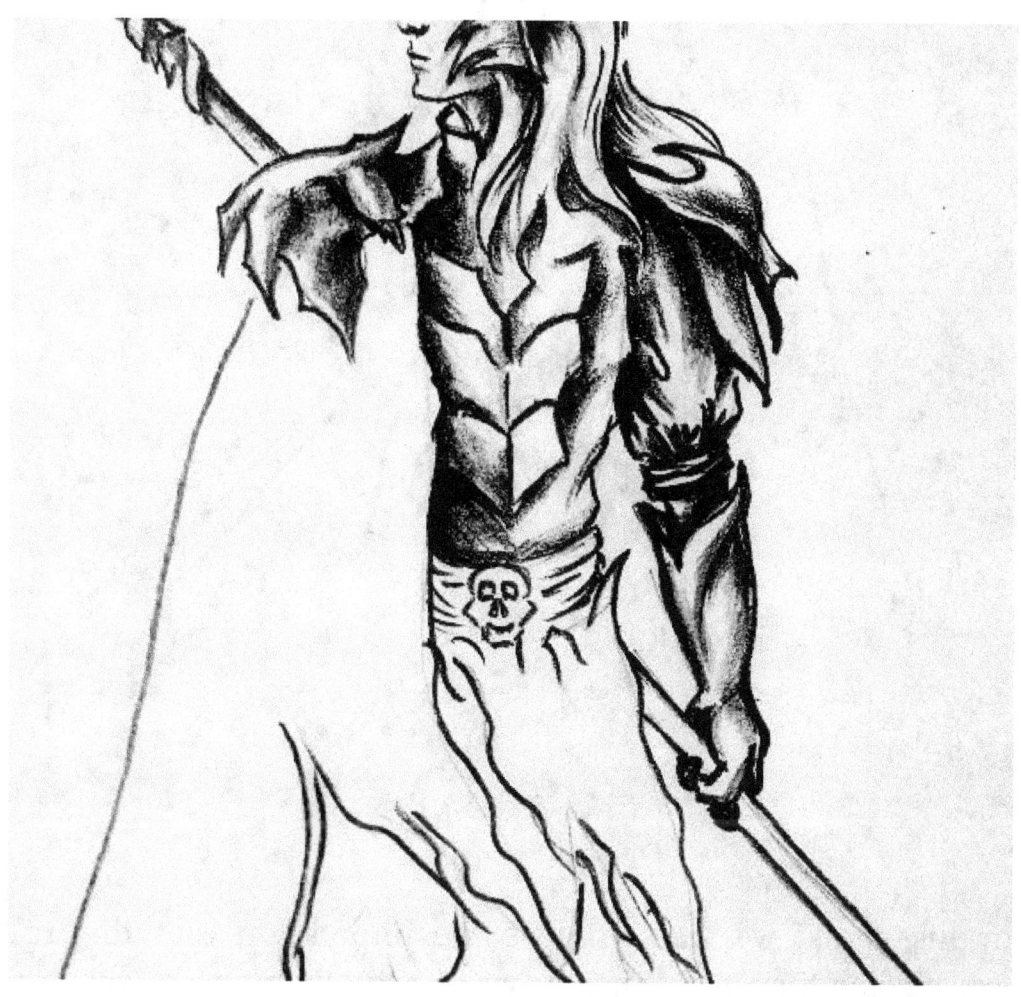

For the arm, remember that the rest of his body is casting a little bit of a shadow over it as well. It's important to remember when it comes to shadows that there are hues of them – there is not just "dark" and "light," but instead a variety of different shades. Darker means a darker shade and lighter means just a little bit of shadow.

For his pants, we want to give the impression that they're a darker color than the shirt, so we're actually going to shade by taking away. So, fill in the pants with a nice medium hue, making sure that the more covered parts, as in covered by the cape and belt, are darker. Then, take your eraser and erase the parts that will have highlights, or the lighter areas of shade. Don't be afraid here; remember you can always fill in what you need again later.

For his boots, they're a little lighter than the pants, and a little stiff, so the shadows aren't going to flow like the pants do. You can use the same technique for the boots as you did with the pants, filling in and then taking away with the eraser.

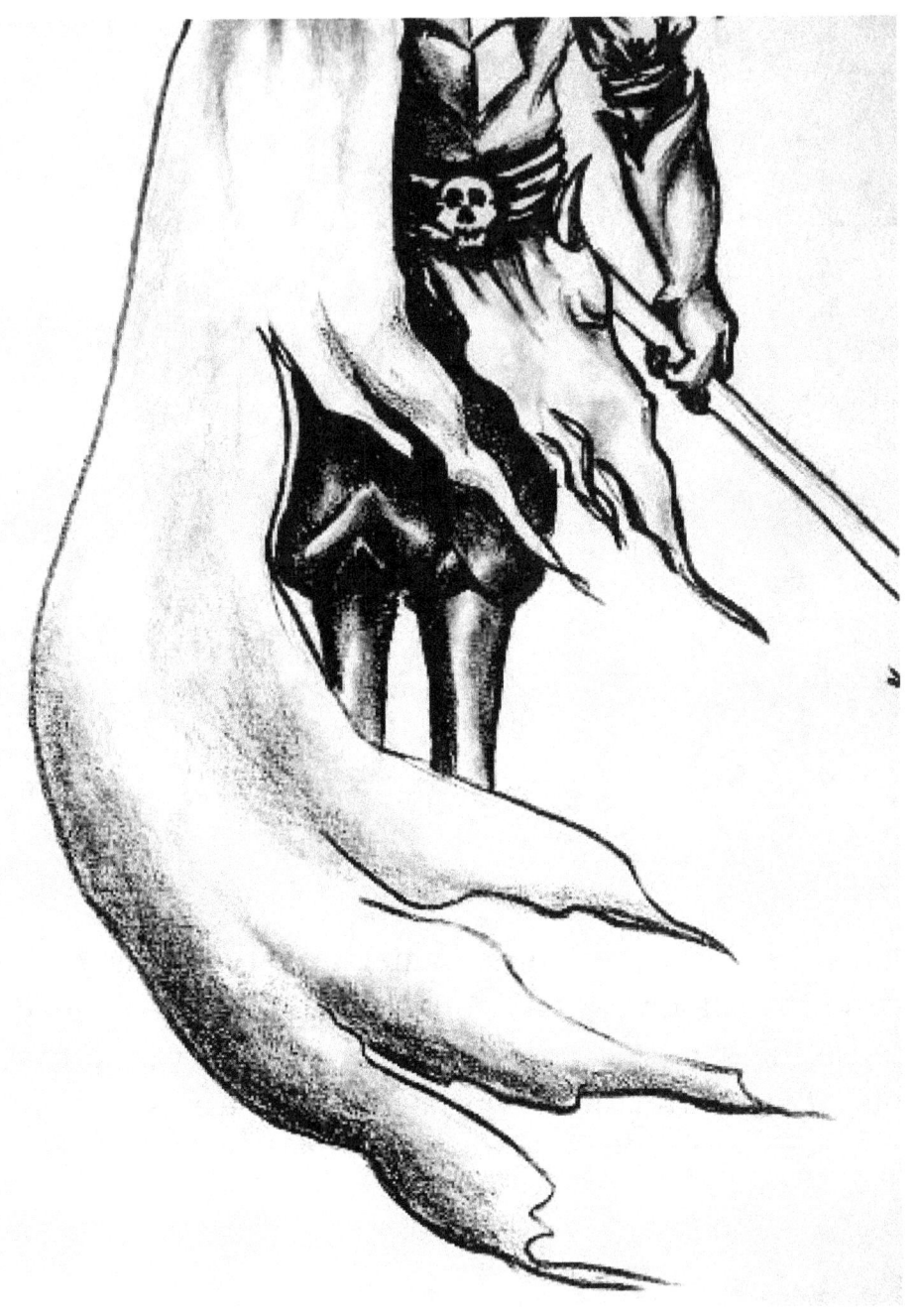

Now for the cape, we want big, sweeping shadows. Use the flat of your pencil, meaning press it flat to the side, and sweep it down. Vary your pressure – the darkest shadows are going to be at the bottom and the harder you press, the darker you get.

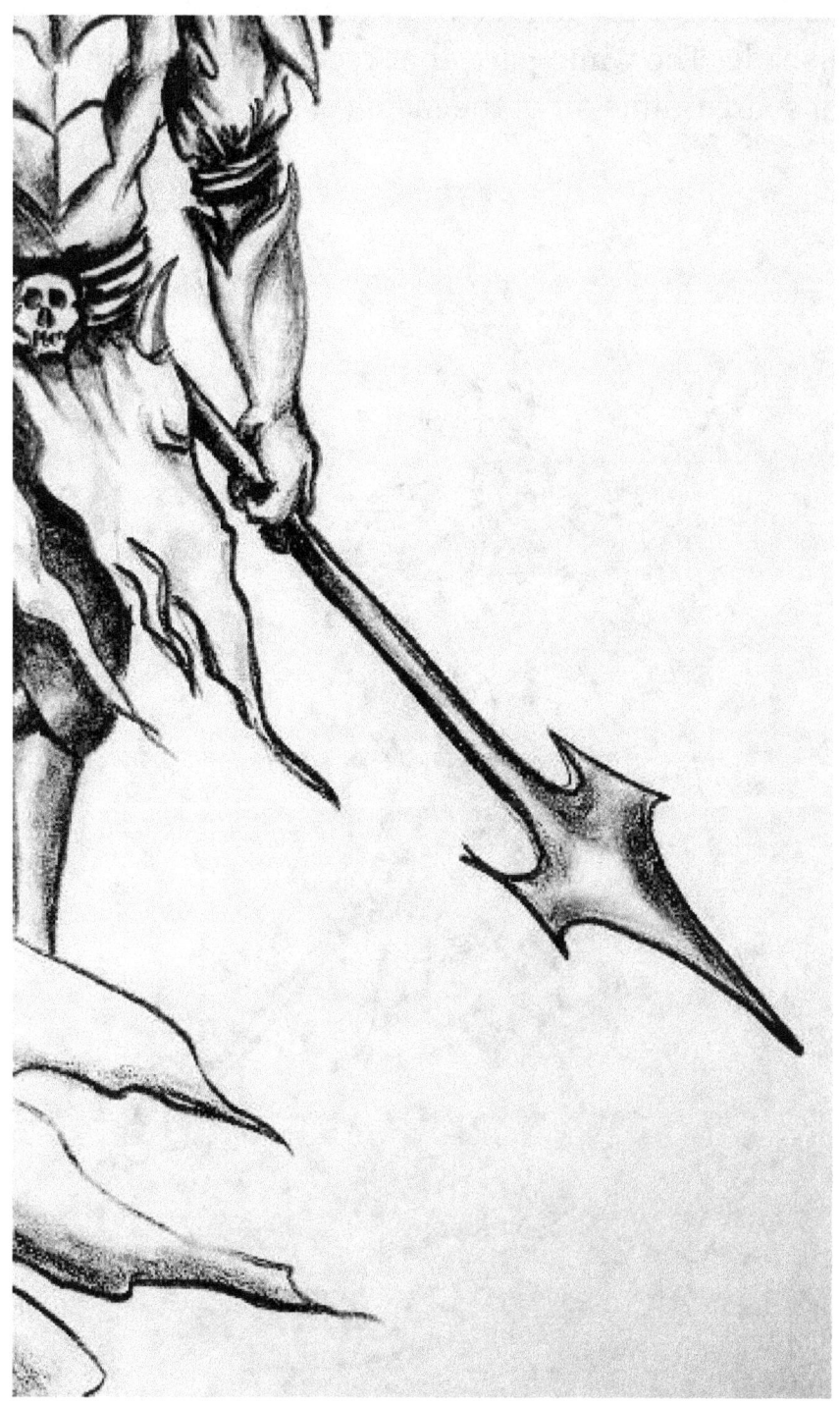

For our Warrior Lord's weapon, remember that it is metal. The closer to his hand the darker the shadow will be, as his body is casting shade. The white part, that receives no shading, is where the light source glints off of the metal.

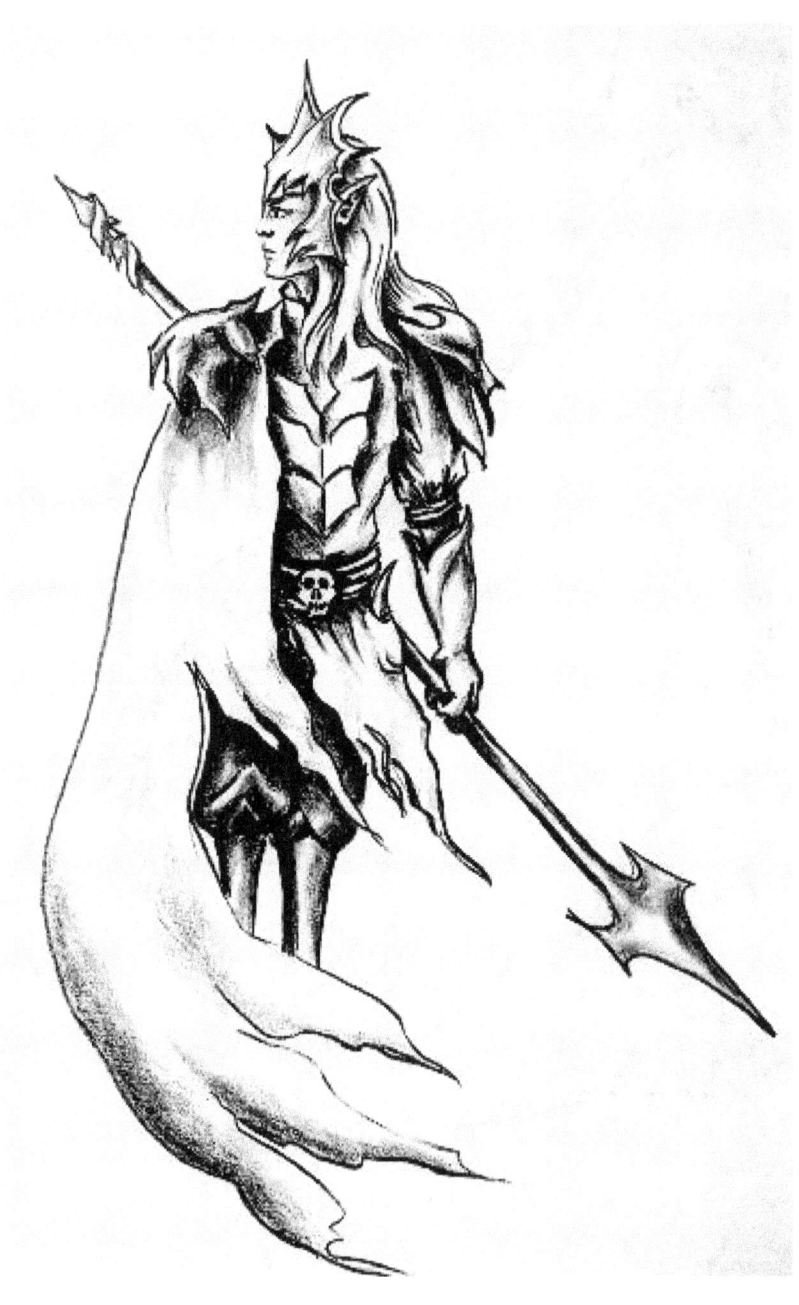

At last, here is our Warrior Lord in full armor, standing regally on the battlefield!

Chapter 2 – Warrior Lady

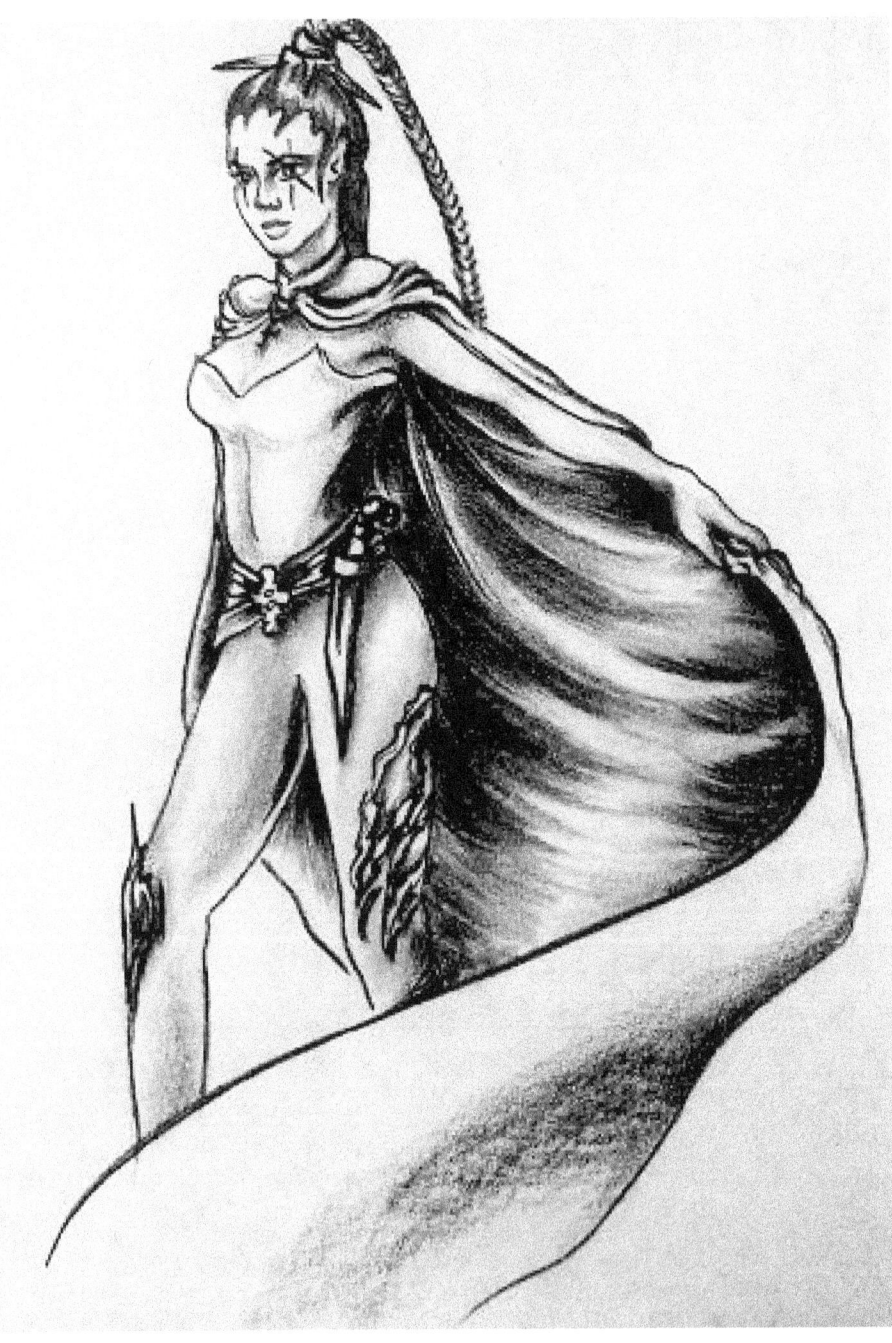

The Warrior Lady is another highly important character when it comes to fantasy art. She can be a hero, a villain, a love interest, or just a general butt-kicking character that you meet along the way. You definitely want her to stick with your viewers, though, so make her beautiful and powerful!

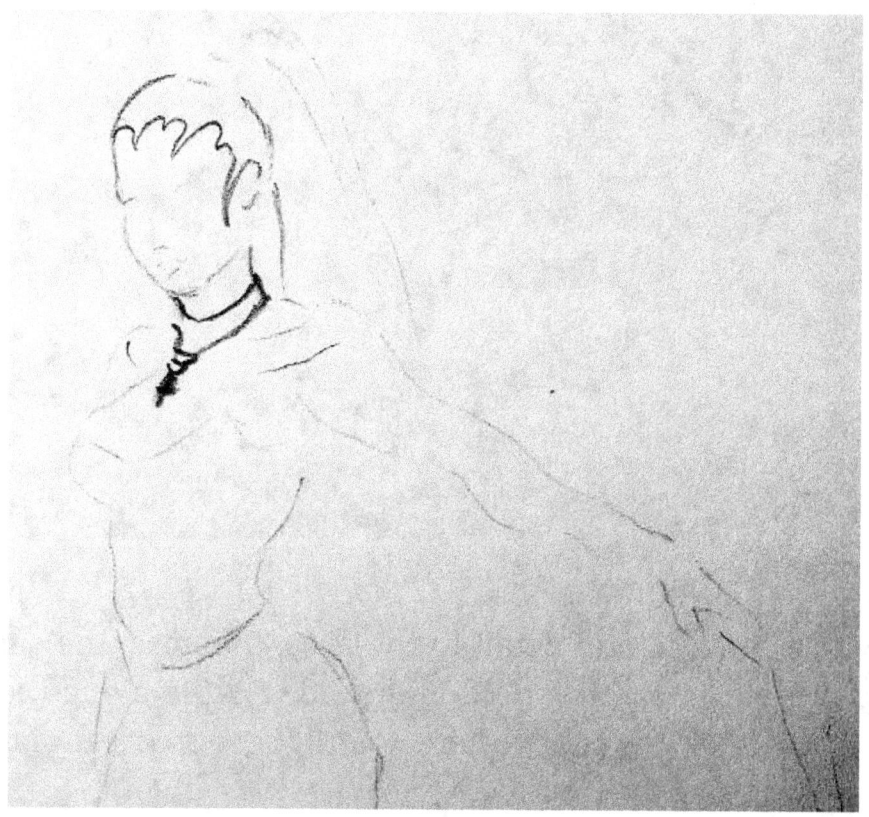

First we're going to sketch a basic outline of positioning and features. Then, carefully bold some of the lines, such as the hairline and the necklace – these are the features we really want to stand out

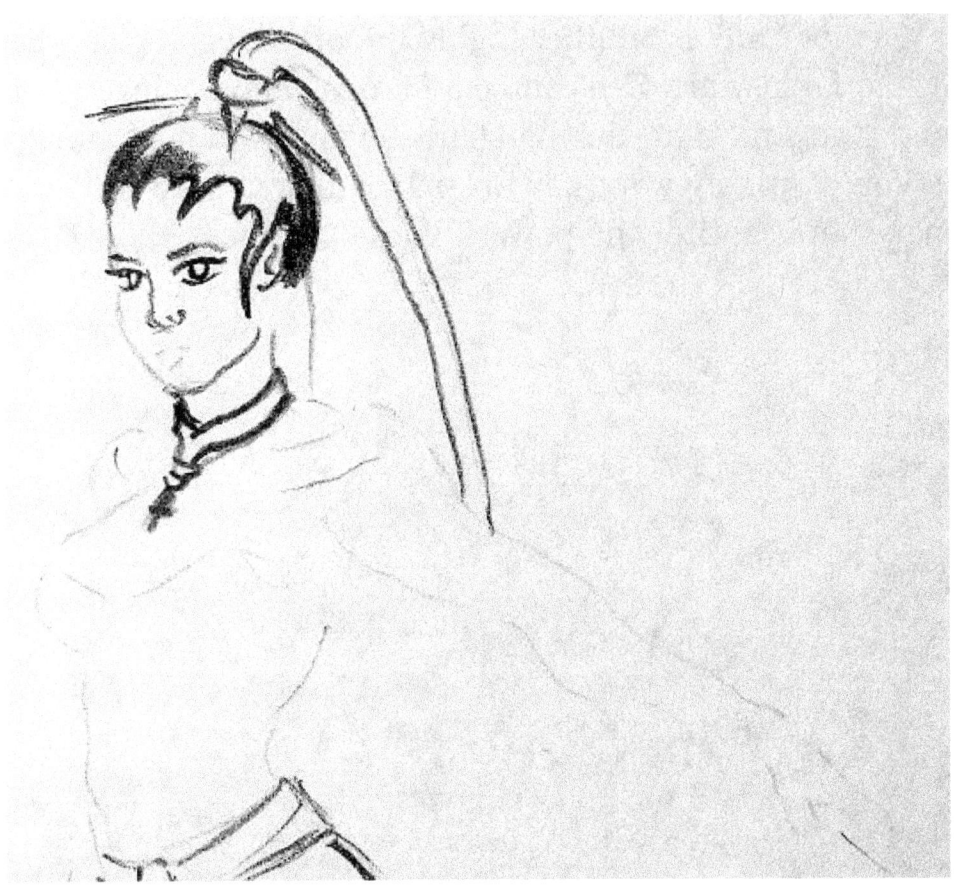

Now we're going to add detail to the eyes, the nose, the ear, and the hair. Make your lines bold and shade a little along the way, just to make sure you know where your light source is for later.

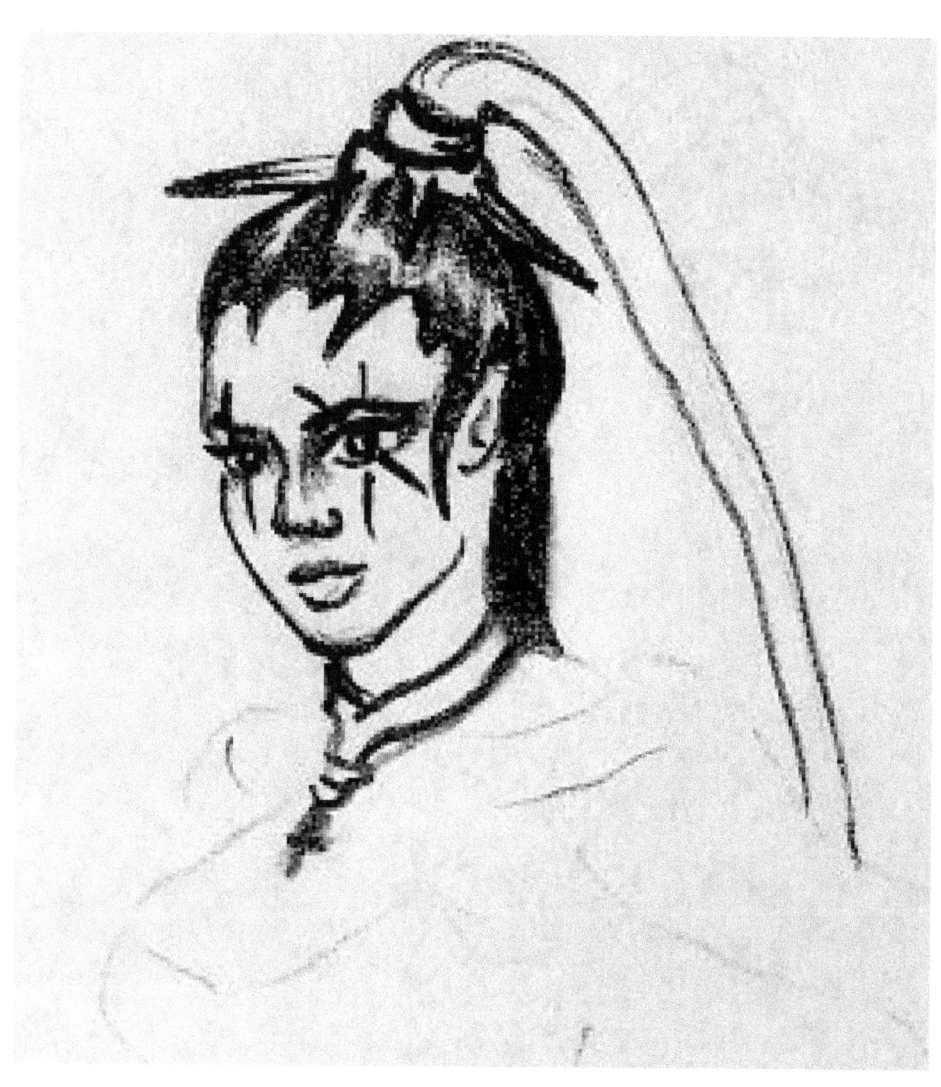

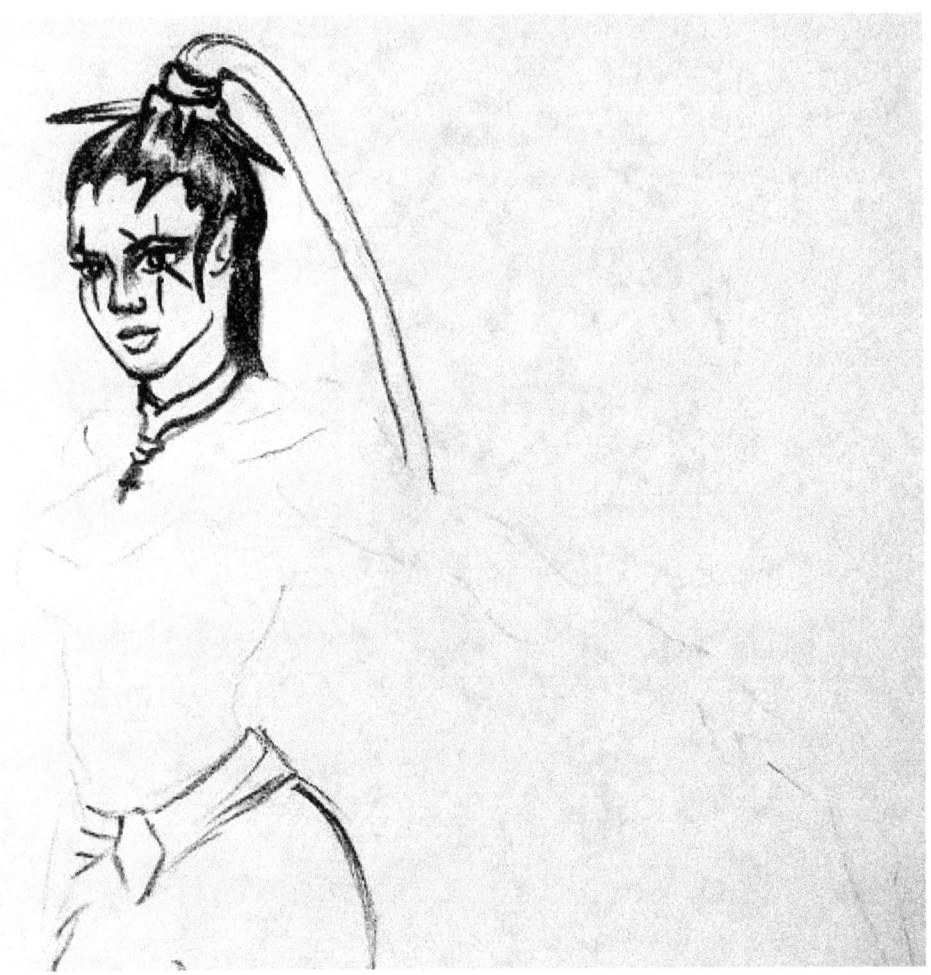

Now we're going to add even more detail, really make the face stand out. Outline the hips as well as we get ready to work on those, and make sure that we can tell her hair is dark – use the technique of erasing away the highlights.

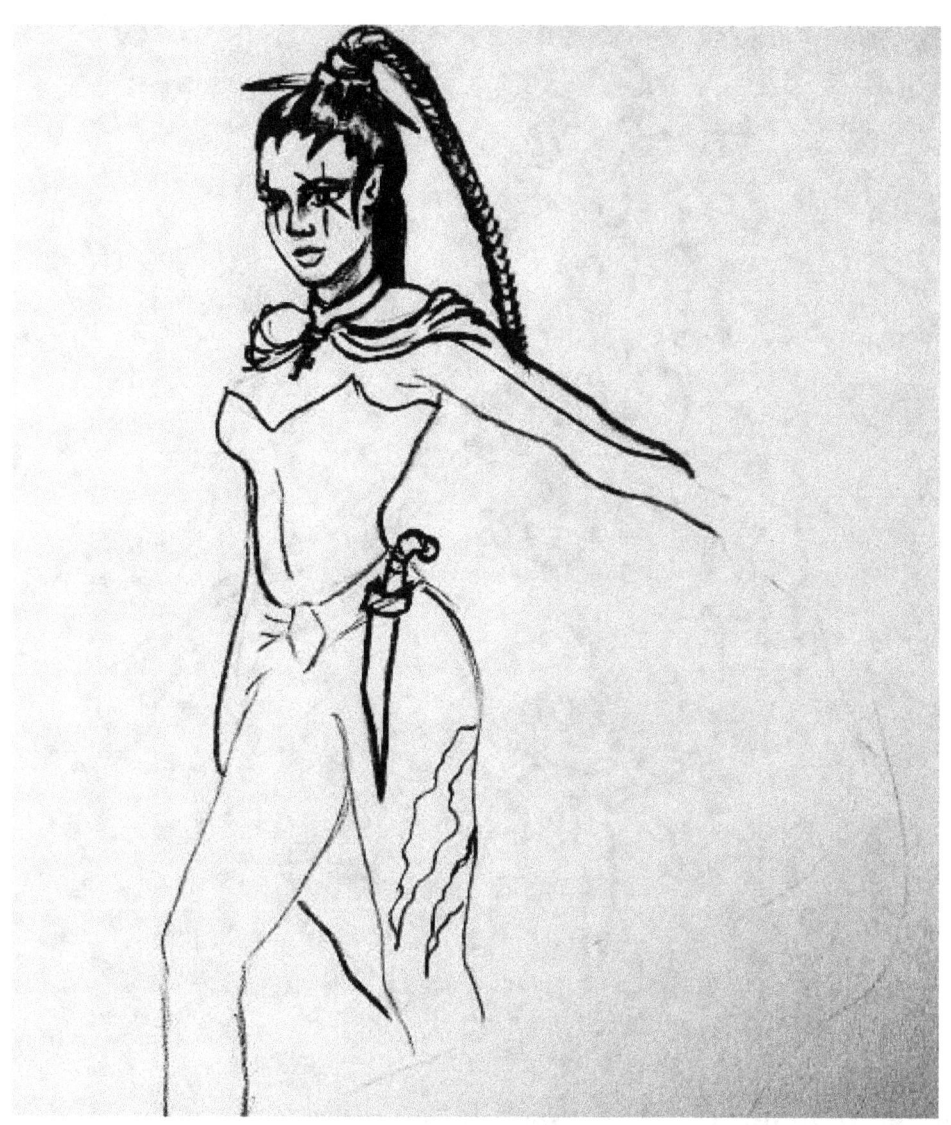

We're going to bold the rest of the lines, excluding the cape, and start working on the leg detail as well as the detail of the braid and shirt.

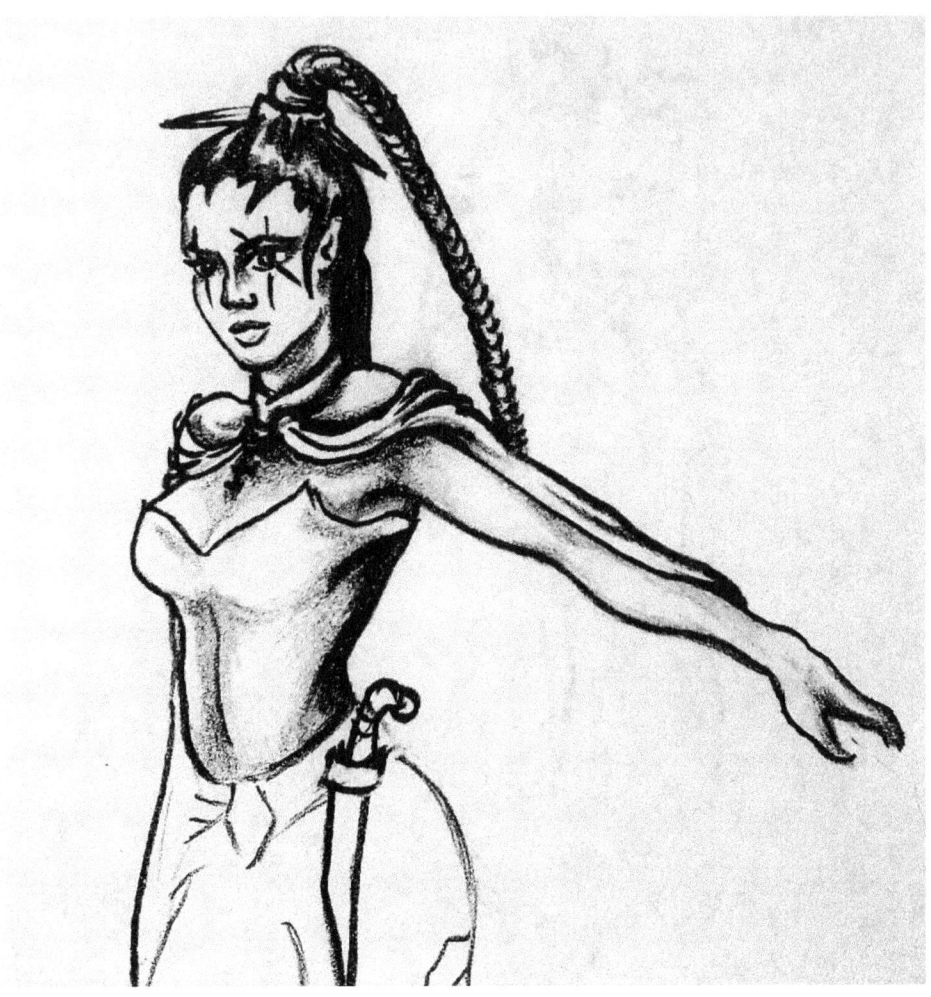

Now we're going to fill in the details and shading of the arm and top – remember where your light source is!

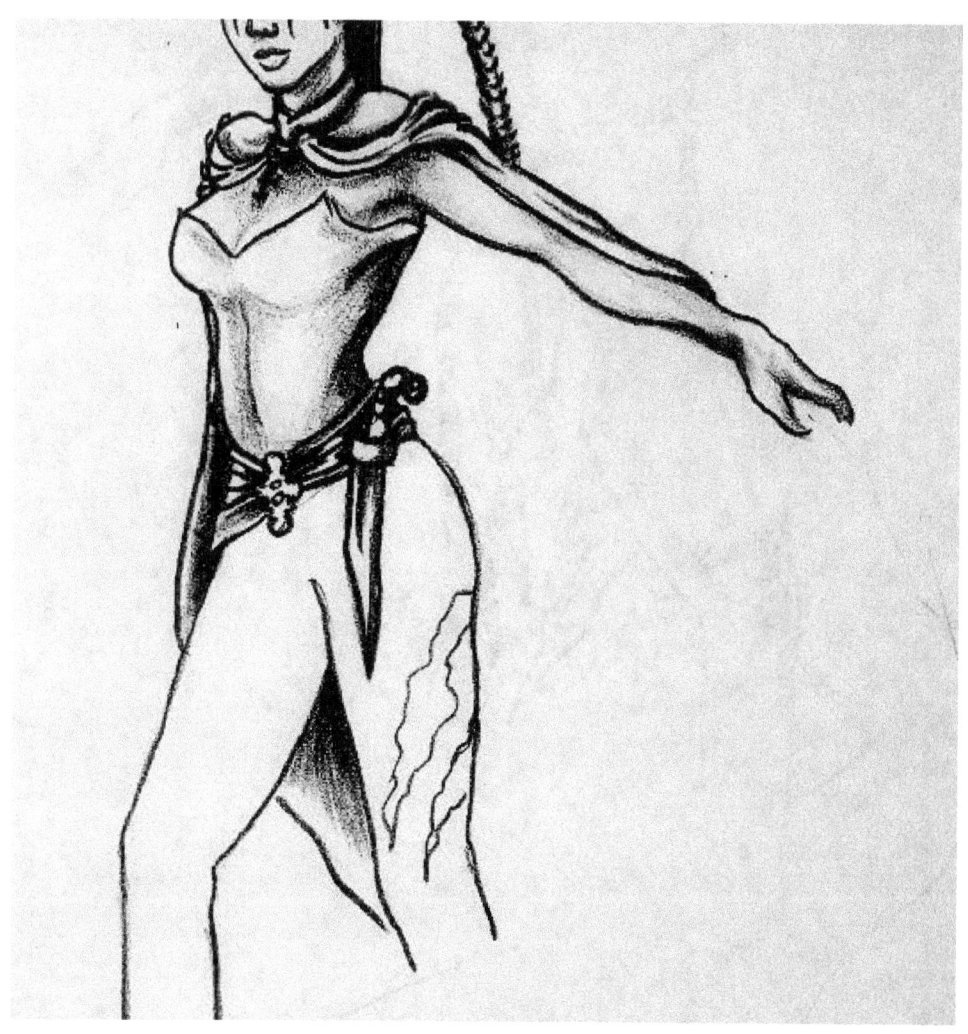

When you're working on the belt and the dagger, remember that the belt is cloth so the shadows will flow. The dagger is metal, so the shadows will be sharper, and there will be a glint of highlight because it shines.

As we're shading the legs, remember that her outfit is a little shiny. The shading on the tears will be a little difficult – the cloth with cast shadows, so shade carefully.

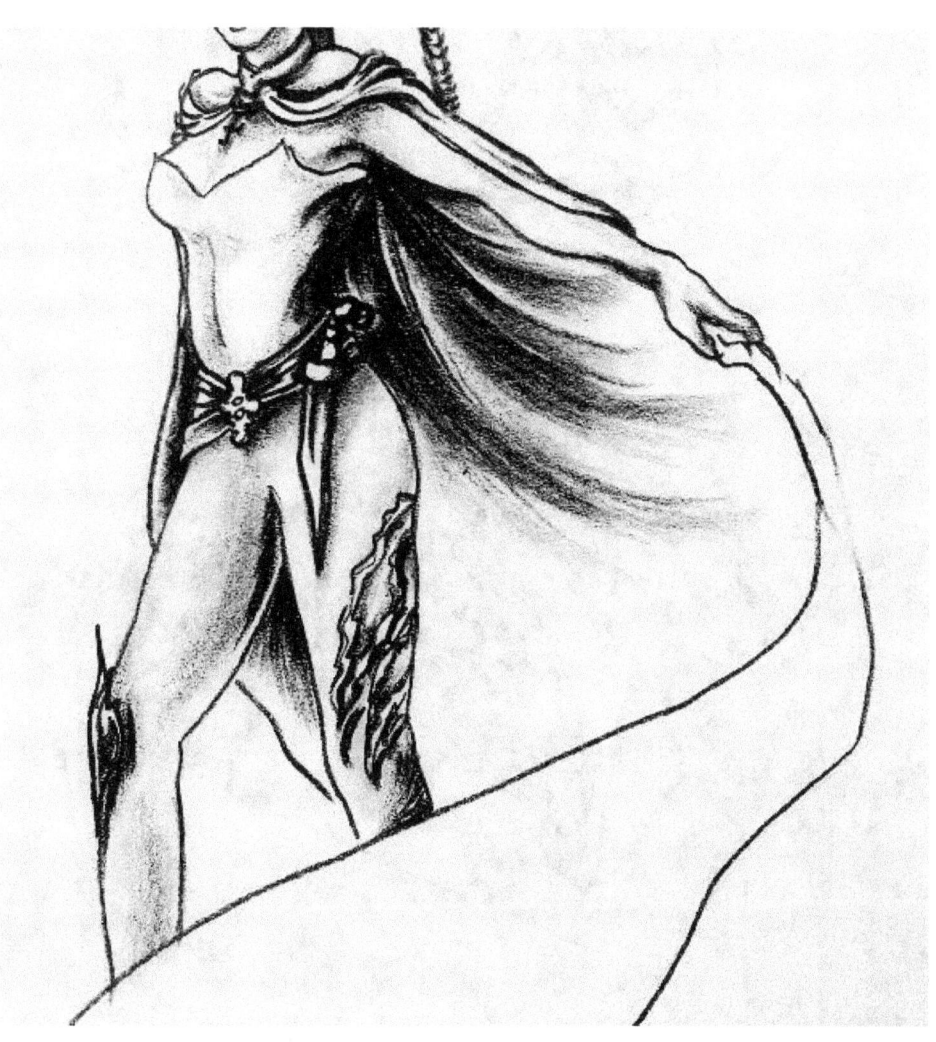

When shading the cape, use long, sweeping lines, kind of like we do with hair. This cape flows in the wind, and we want to show that with our strokes.

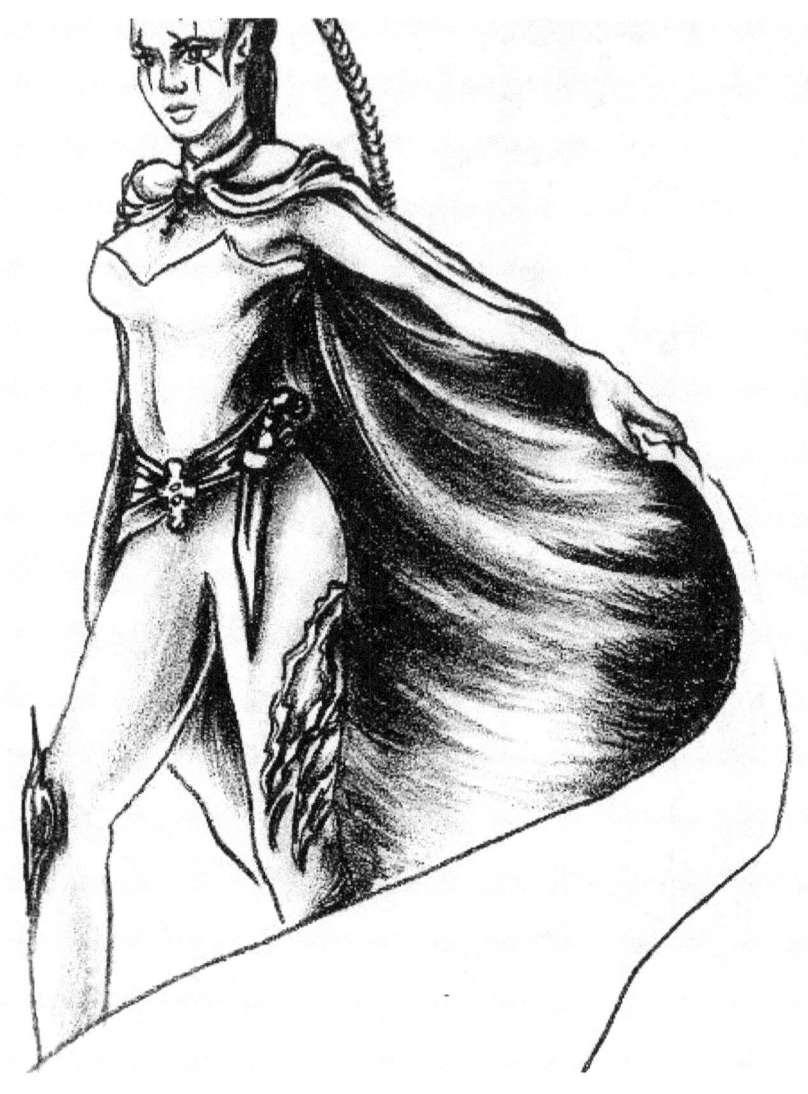

Add a little bit more detail to the cape, really highlighting that it's a dark color and erasing the lights and shadows out as you go. This is where our Warrior Lady gets her powerful stance!

Finish up the cape with the flat of your pencil, pressing and releasing to create a myriad of shades.

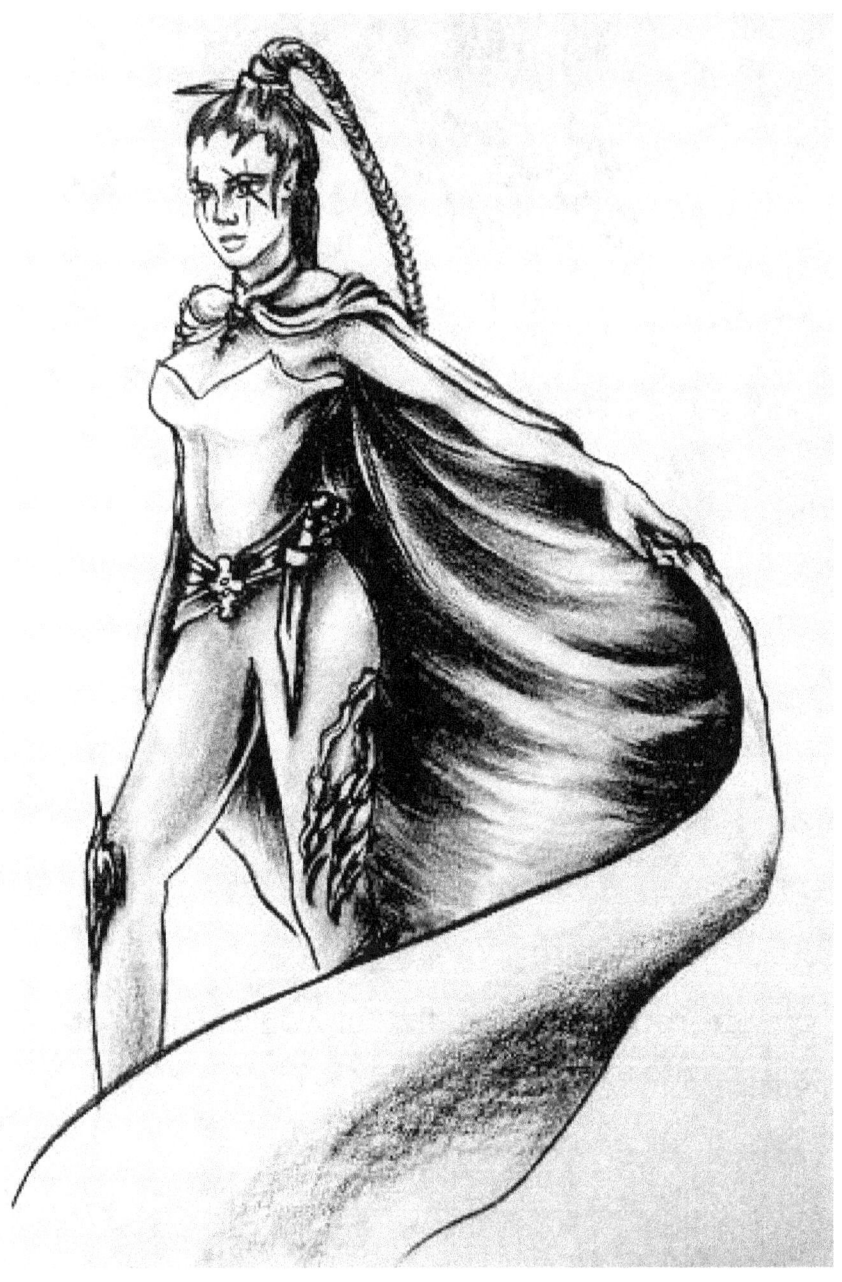

Voila! Our Warrior Lady stands proudly on the battlefield, looking across and assessing her enemies with confidence.

Chapter 3 – Unicorn

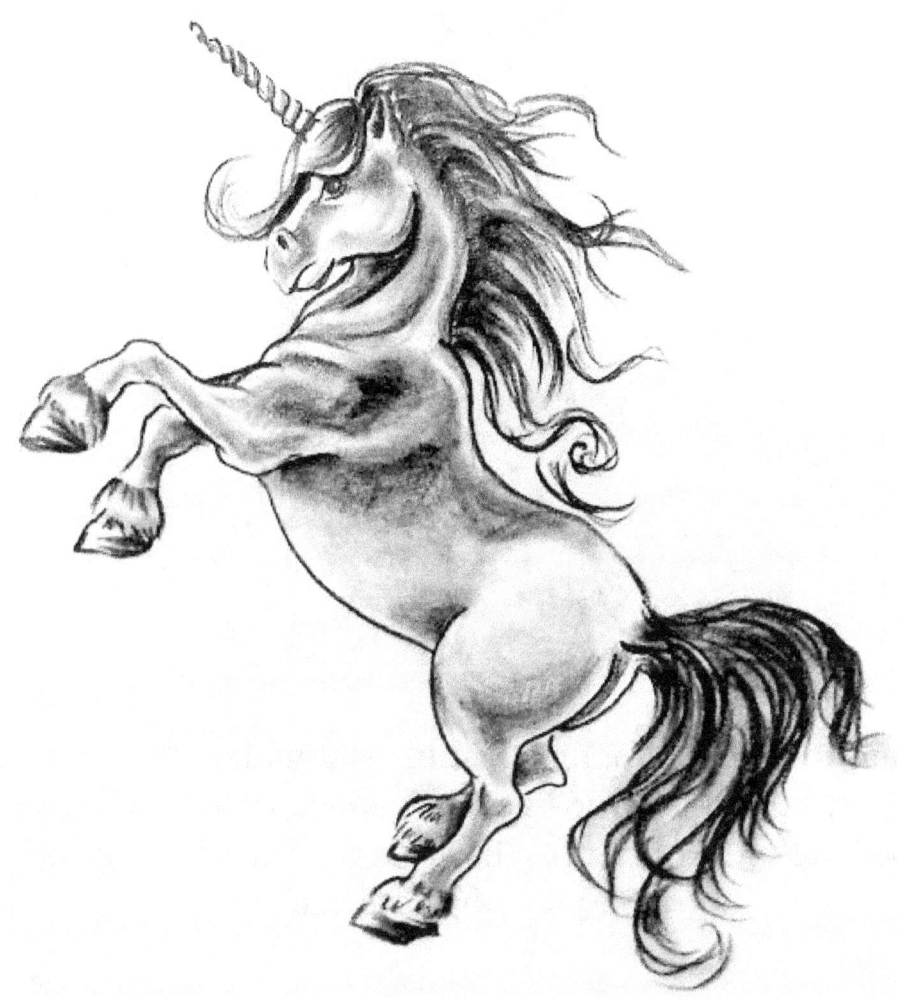

Beasts are incredibly essential to a fantasy world. They are just as important as our heroes, and are fantastic creatures in their own right. Unicorns are a classic fantasy beast that can be a lot of fun to draw and experiment with.

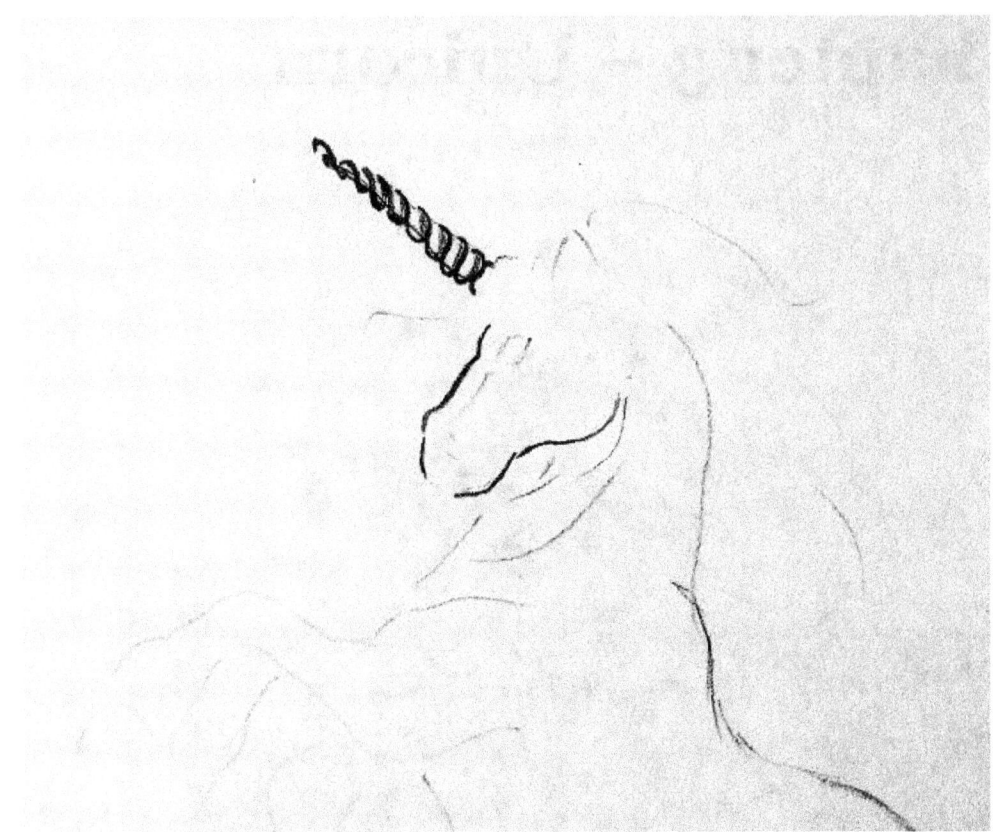

First start with a light outline, getting everything into place and making sure that the basic lines look good. Then we're going to bold the lines on the unicorn's horn – can't be a unicorn without a horn! – and a little bit around the nose and face.

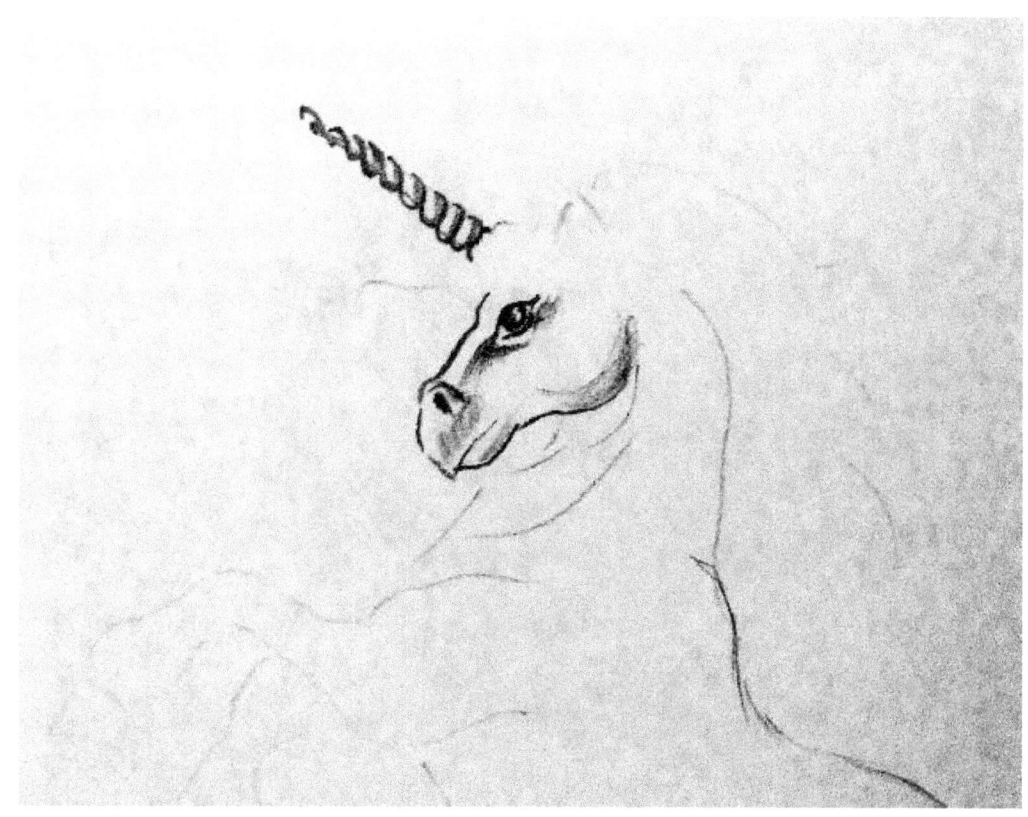

Now we're going to add a little bit of shading and detail. Give the unicorn a gentle eye and a little bit of a curved lip – this is a friendly, but mighty beast and we want the viewers to understand that. Remember where your light source is!

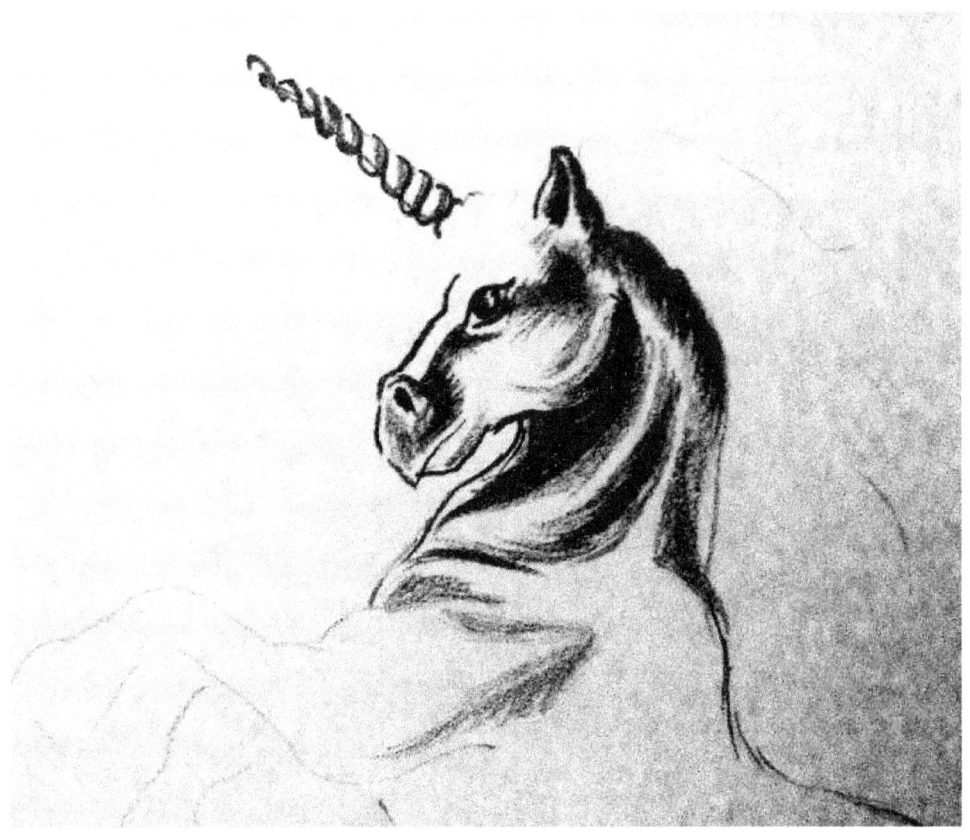

Horses have very powerful muscles, and we want to highlight that as we shade and detail.

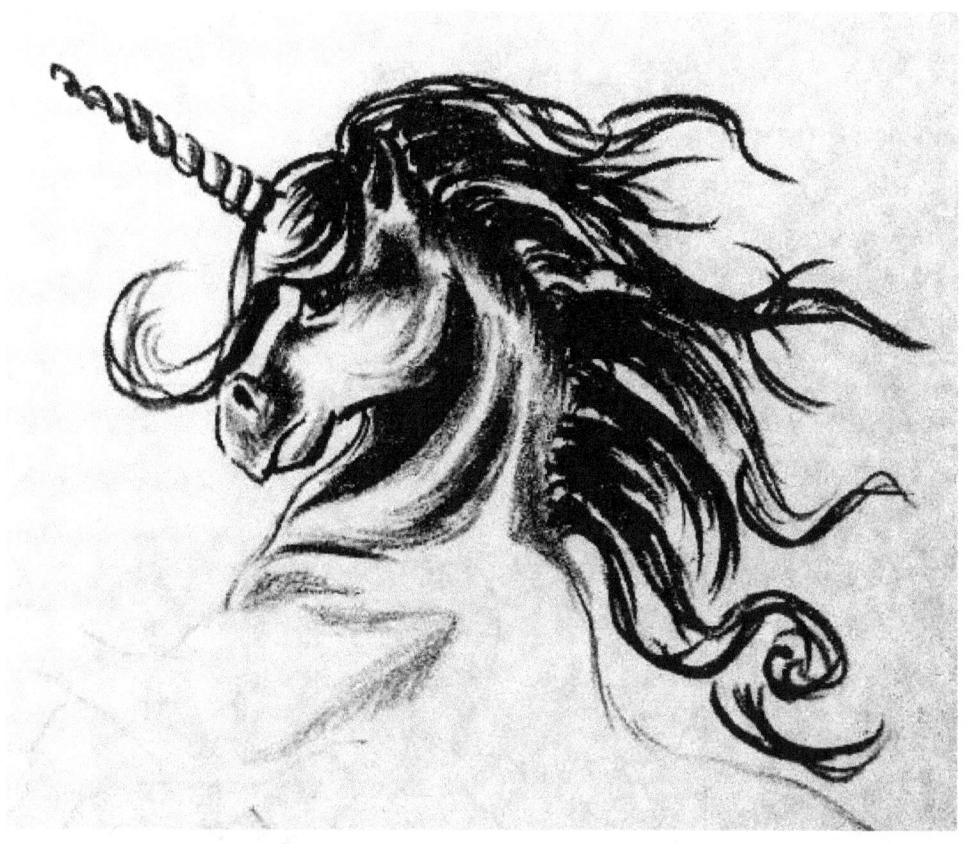

As for the majestic mane, have fun with it! Let your lines flow, really let the magic of the unicorn show. As we said before, this is a mighty but gentle beast – it's powerful but friendly.

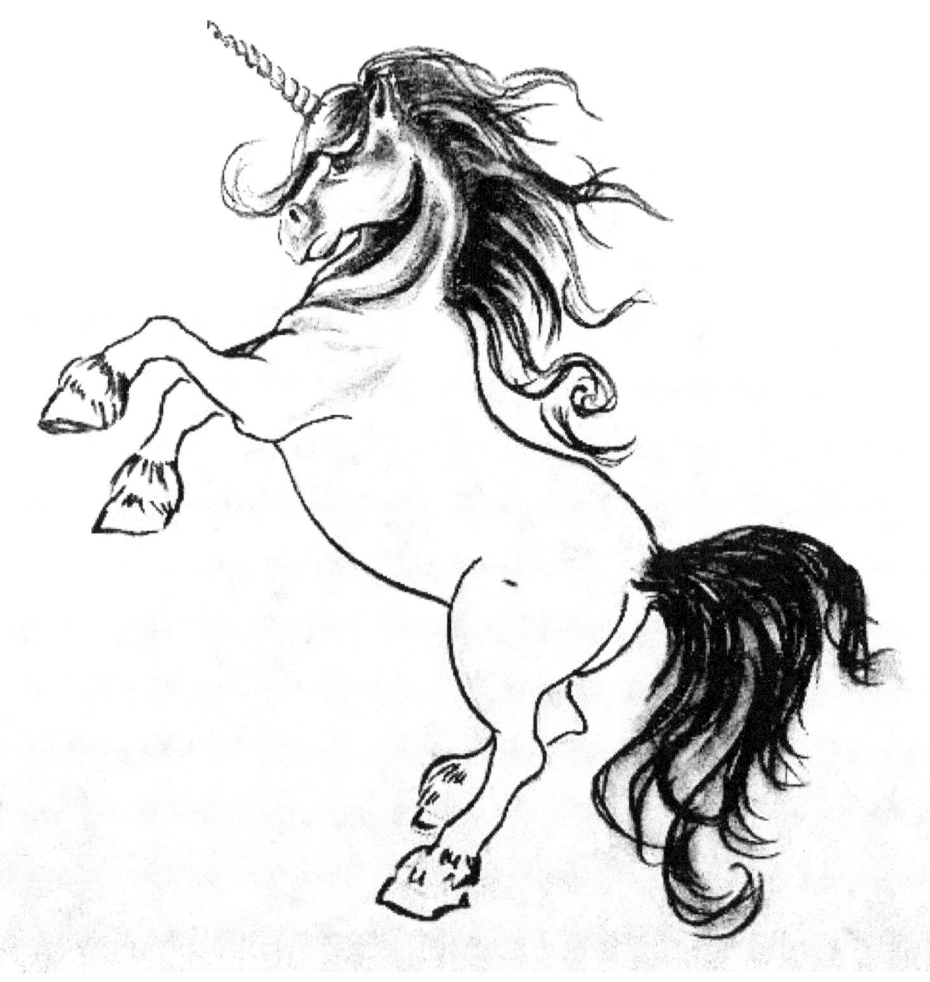

Now we're going to start on the rest of the body. Bold the lines and give the tail the same treatment as the mane, we want them to look similar in style because the hair is a different texture than the rest of the unicorn.

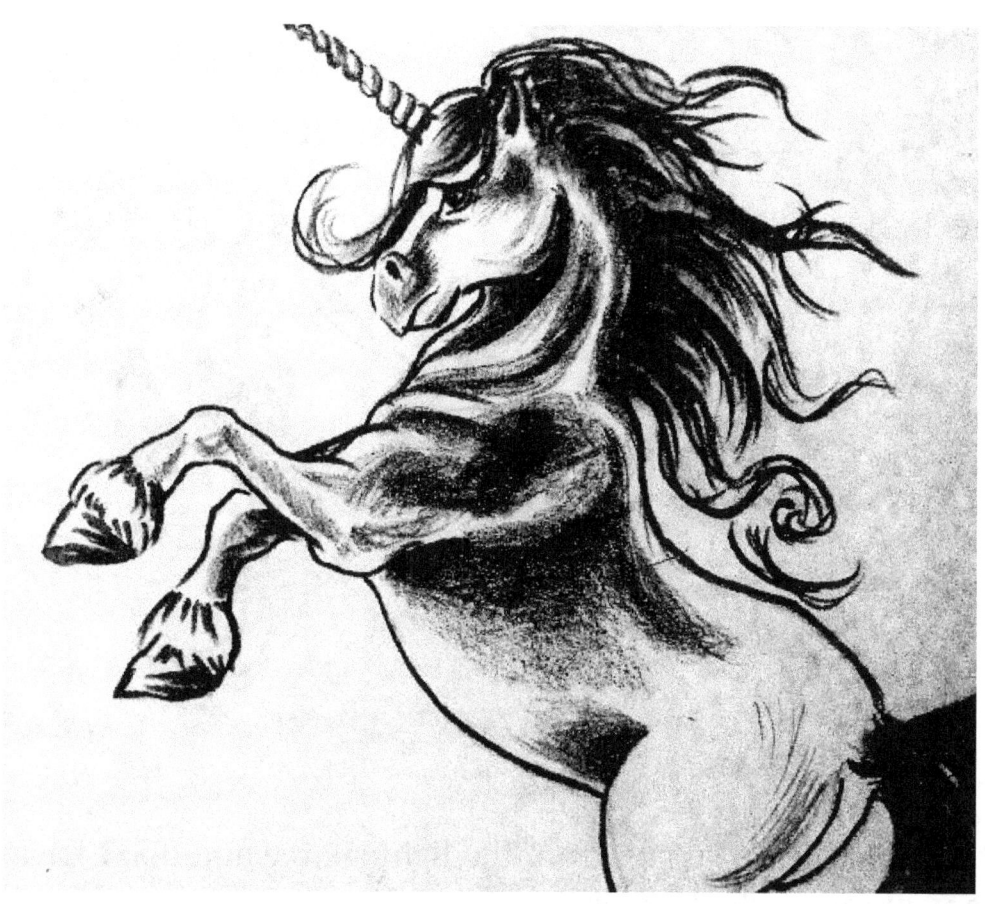

Shade the unicorn's powerful front legs very carefully, using the erasing technique you've learned as well as the flat of your pencil.

The hind legs are farther from the light source and don't have as many dramatic shadows as the rest of the unicorn.

Give the whole thing a little bit of a smudge with a smudging tool or your finger, to give it a smooth, polished look.

Finally, fill in the hooves darkly, using the eraser to erase out the highlights. These are incredibly dark so don't be afraid of pressure.

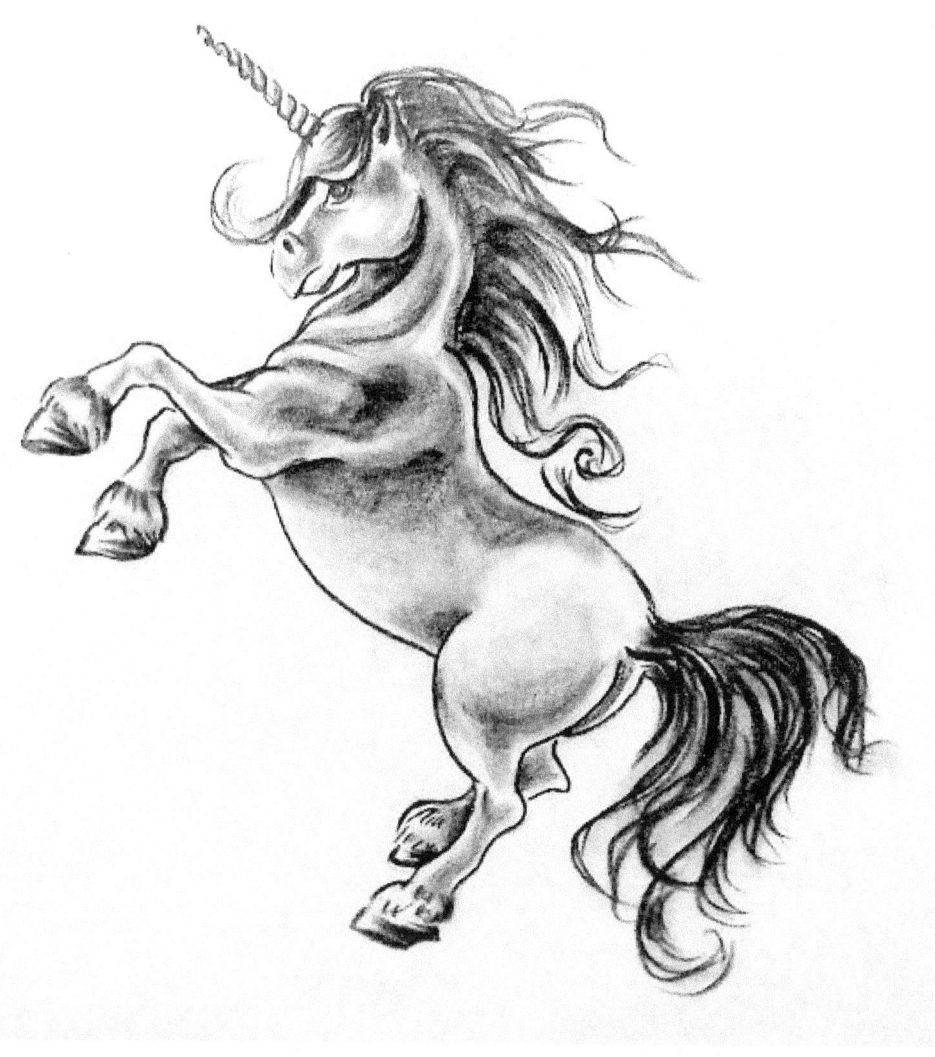

There you have an amazing, beautiful beast to be admired and loved! The unicorn is an awesome fantasy creature, full of magic and power.

Chapter 4 – Pegasus

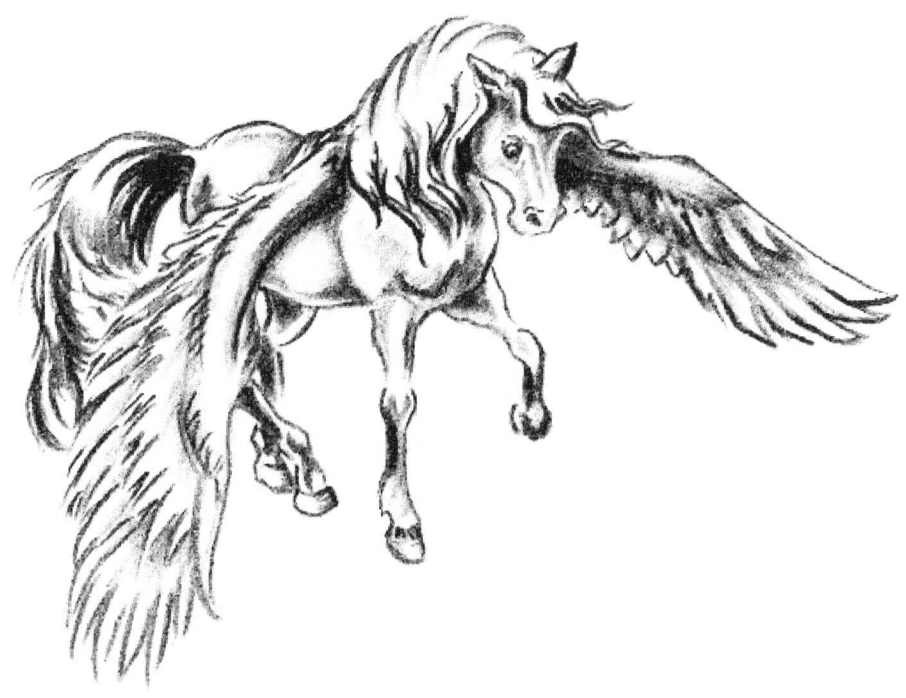

Another beautiful fantasy creature, the Pegasus is like a horse with wings. To take to the skies, our heroes will need you draw them this fantastical beast.

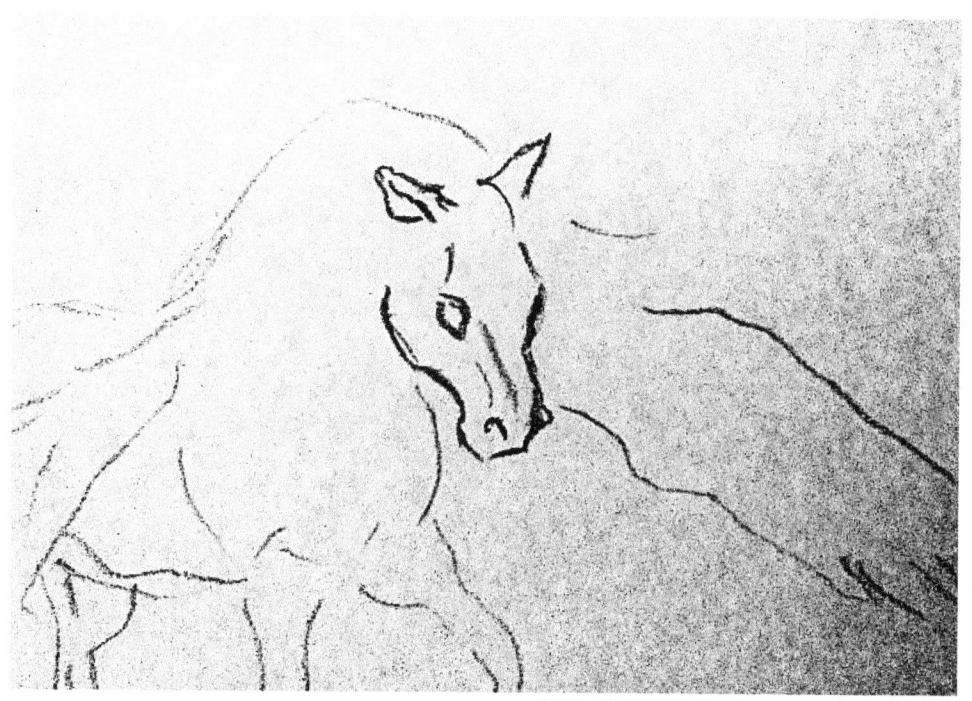

We're going to start by outlining the basics of the Pegasus so that we know where everything goes. Then, we're going to darken the lines of the face, adding a little bit of detail – the curve and such.

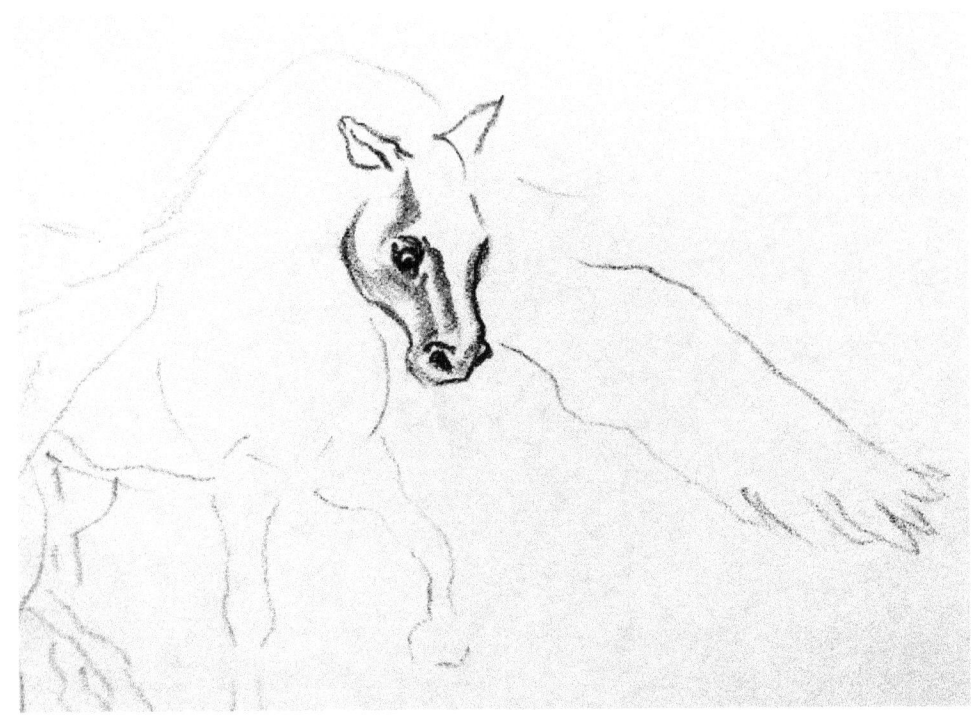

Now we're going to add some shading to the face. This time the light source is in the right hand corner, so shade accordingly.

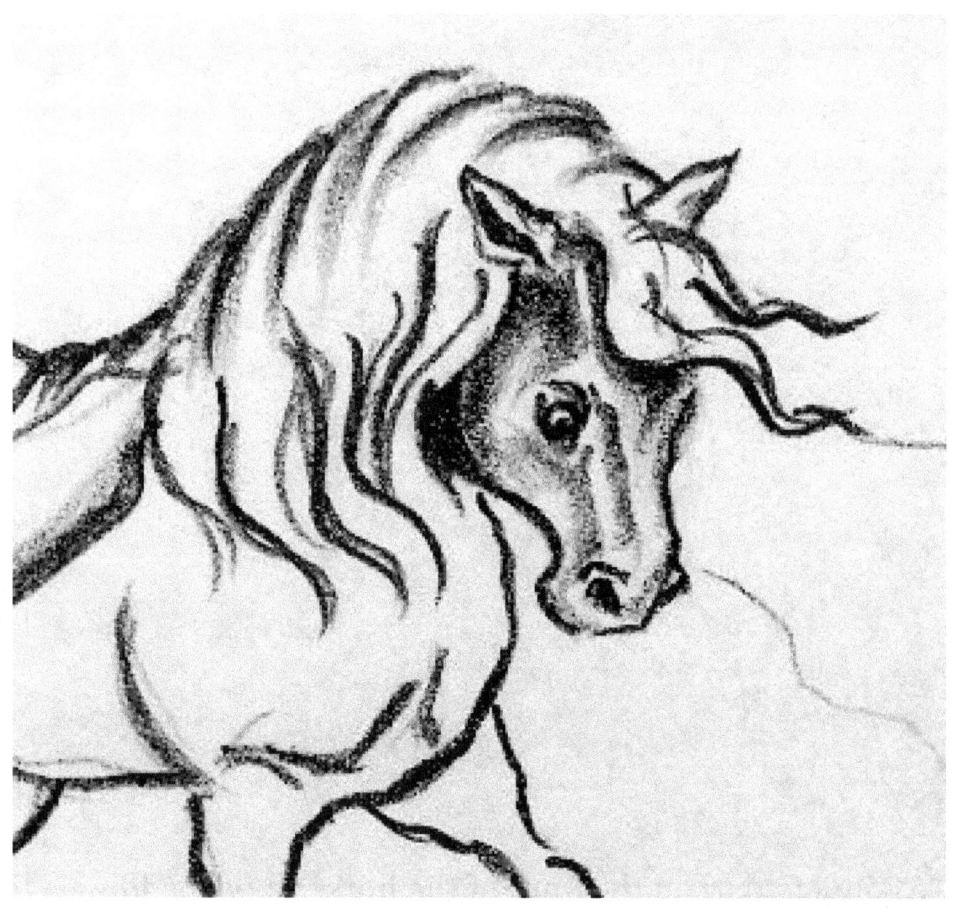

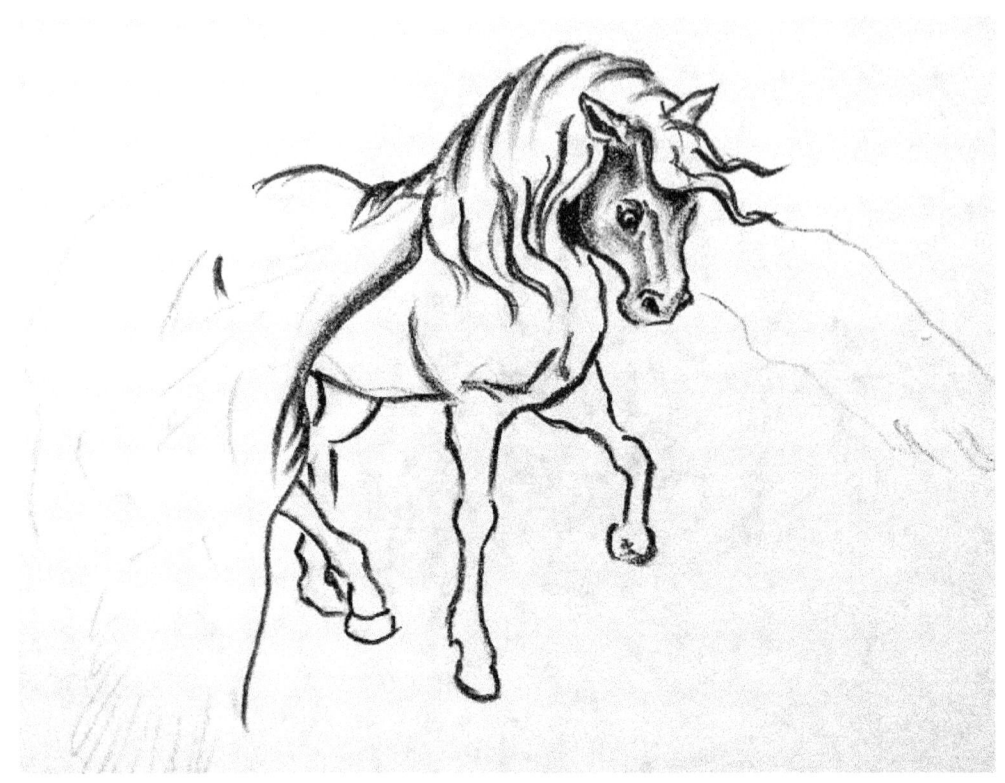

We're going to darken the lines of the horse's body, adding a little bit of muscle detail and detail in the mane.

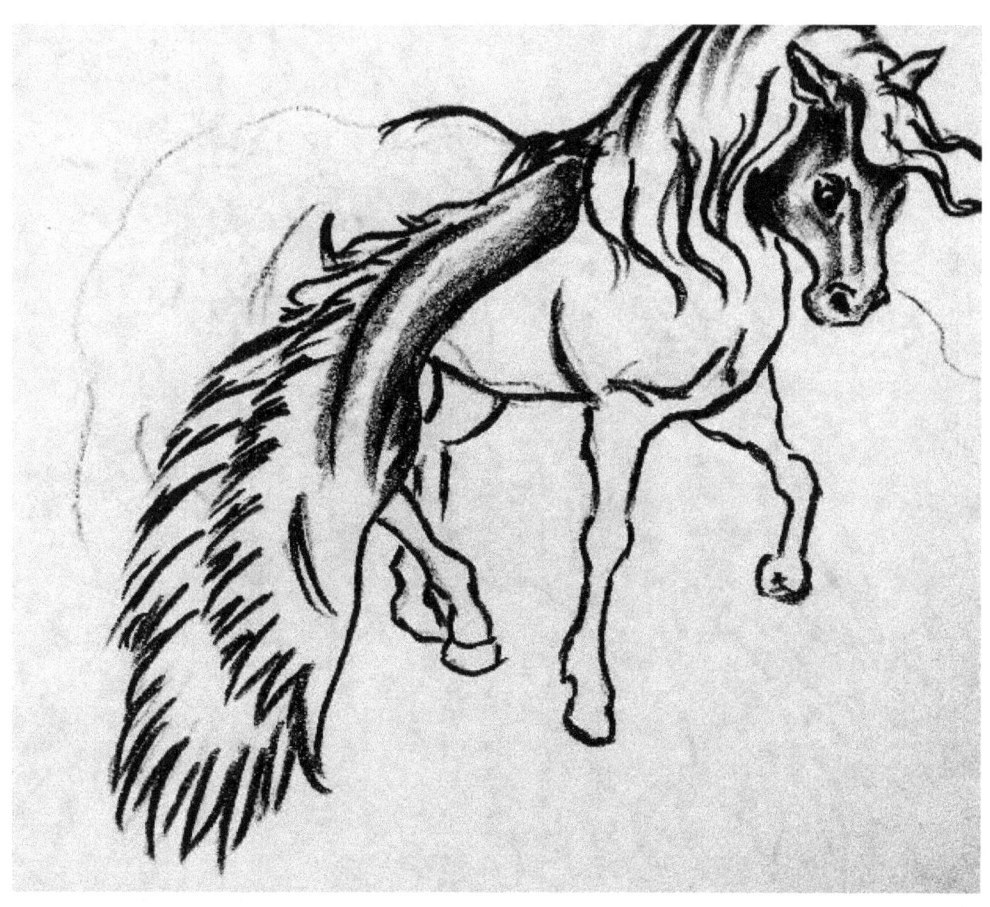

Now we're going to work on the wing detail. Remember to use gentle, smooth strokes, as these are feathers after all.

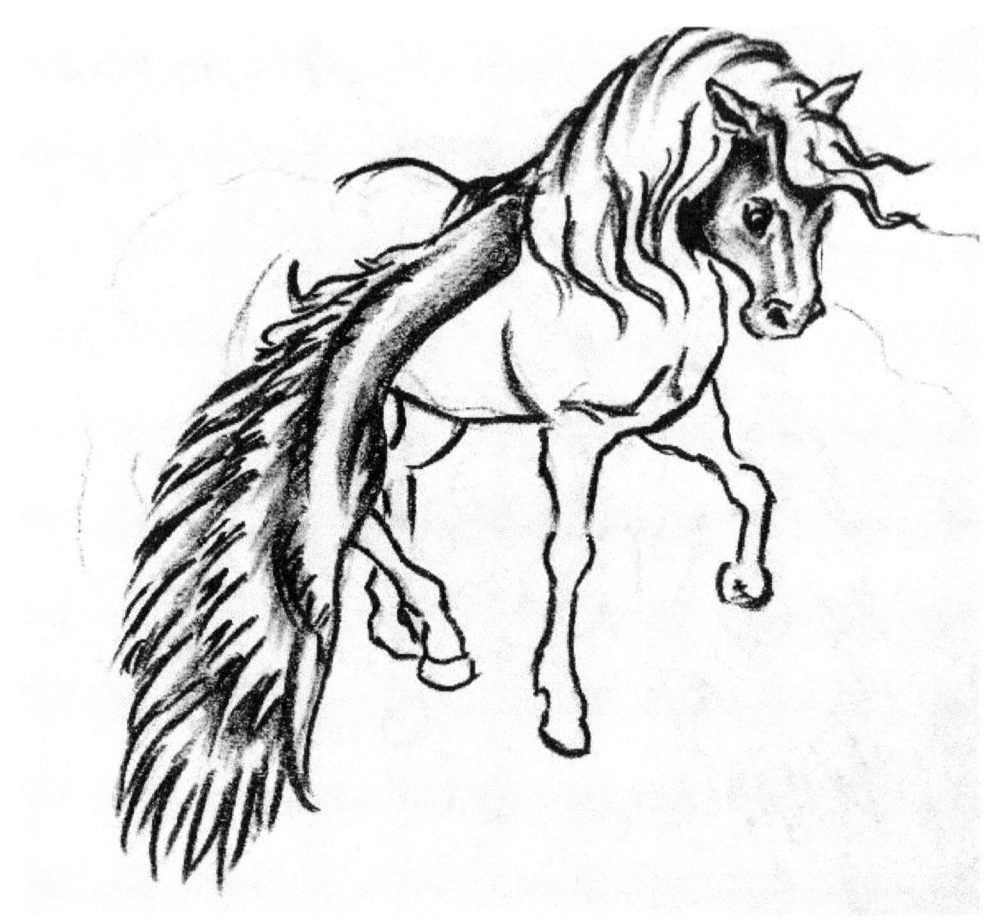

Shade the feathers carefully.

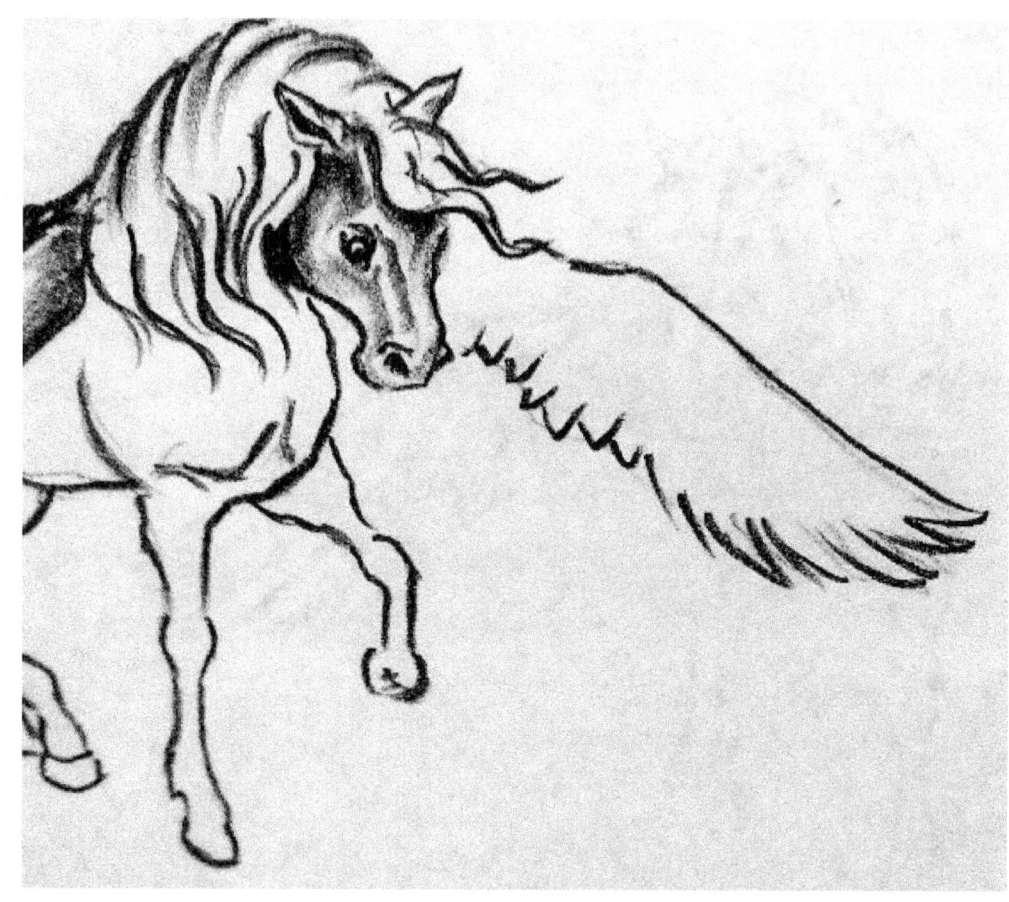

Now we can outline the back wing as well.

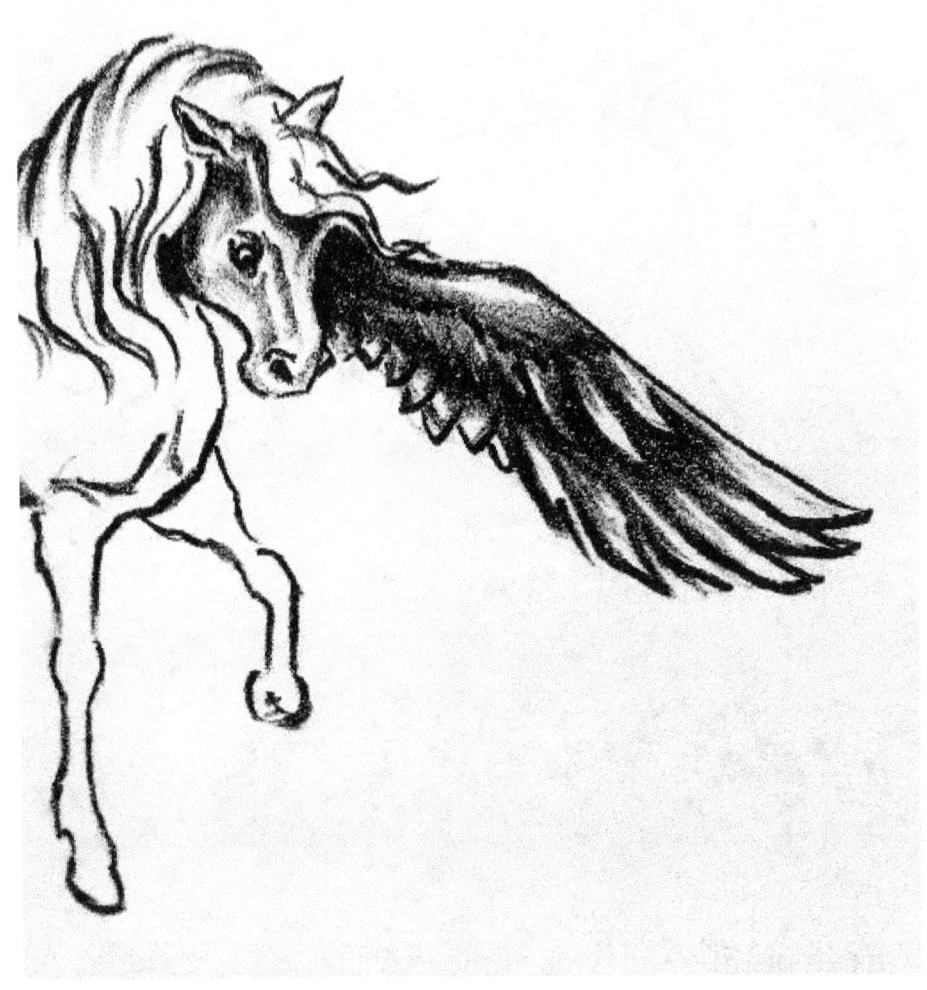

This one will be mostly dark as it is away from our light source. The Pegasus casts a shadow after all, and the wing is in it.

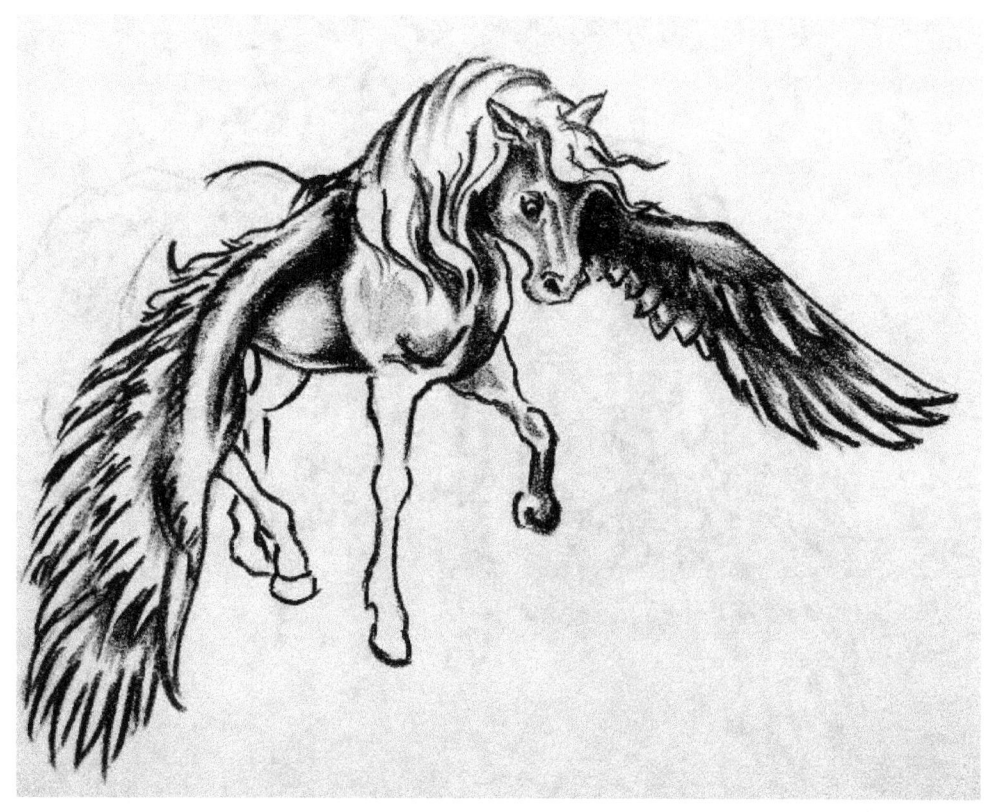

Now we're going to start shading the muscular torso and one of the front legs. Use pressure wisely, don't be afraid to press down or erase.

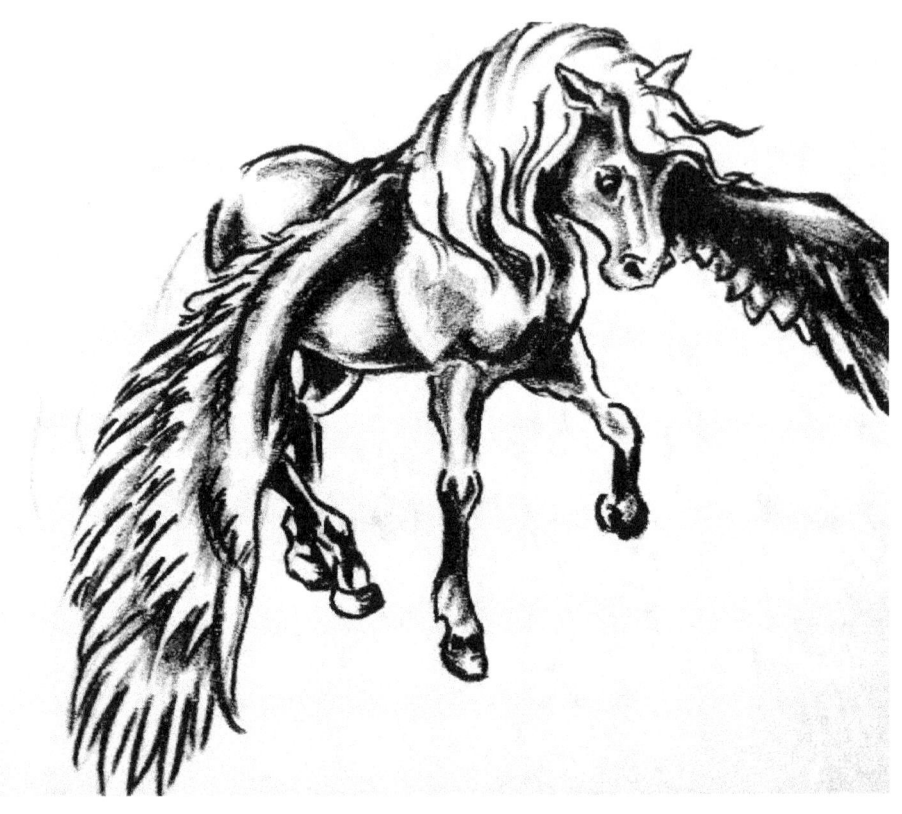

Now darken it a bit, adding in the shading for the legs. Our Pegasus isn't white, so we need to show that through shades of grey.

The tail we want to be flowing and free, so keep that in mind when making your strokes. Shade using the flat of your pencil, and remember that it will be darkest closer to where the tail begins.

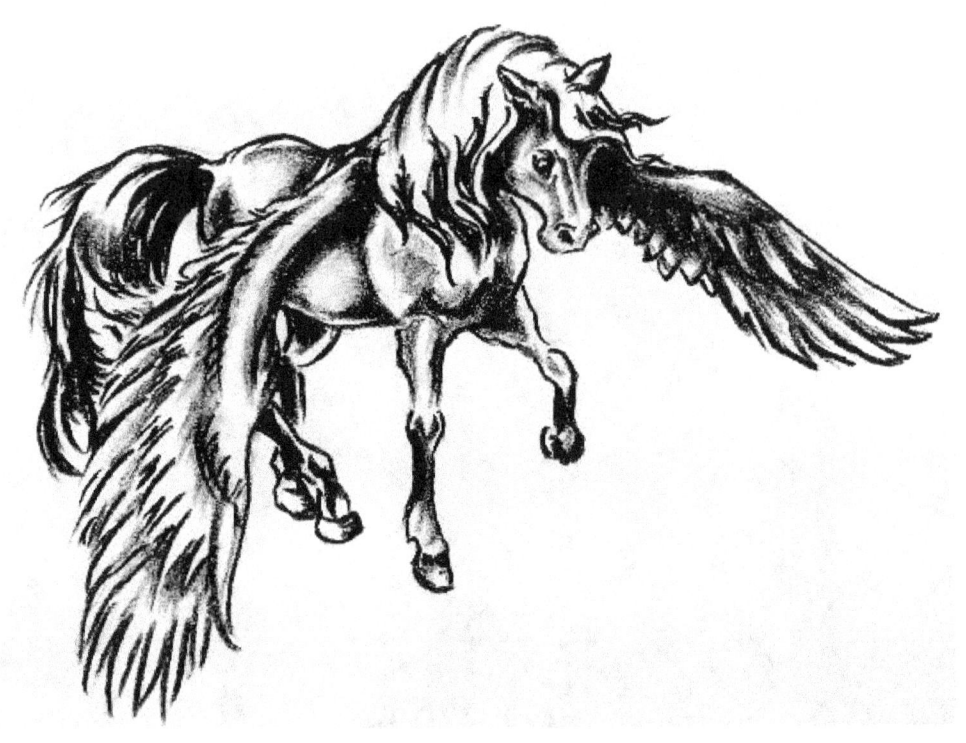

And finally we have a beautiful Pegasus, ready to help our heroes take flight over the battlefield and through mystical places!

Chapter 5 – Witch

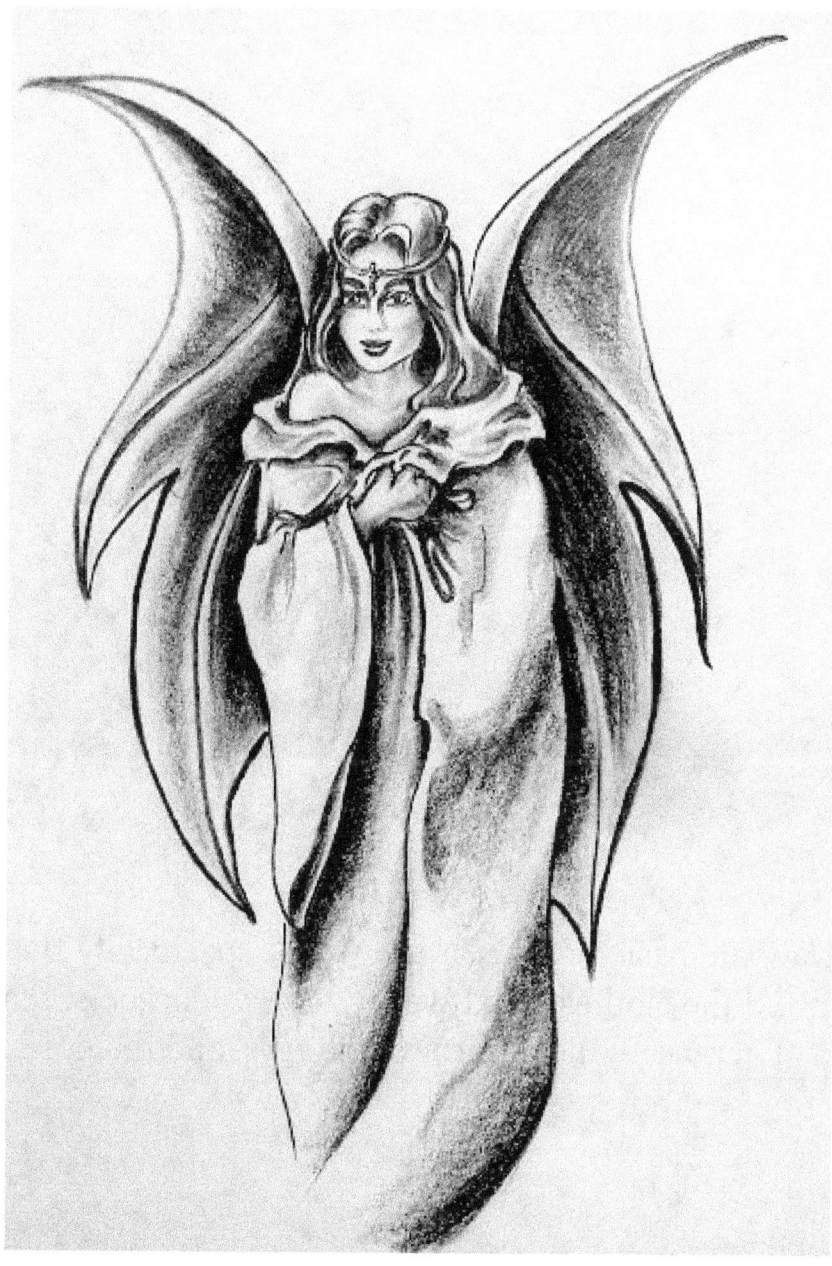

The witch is usually a villain, but can sometimes be a powerful ally. Witches are scary, full of magic and power and secrets that

only they know, so we want to portray that with our drawing of the witch.

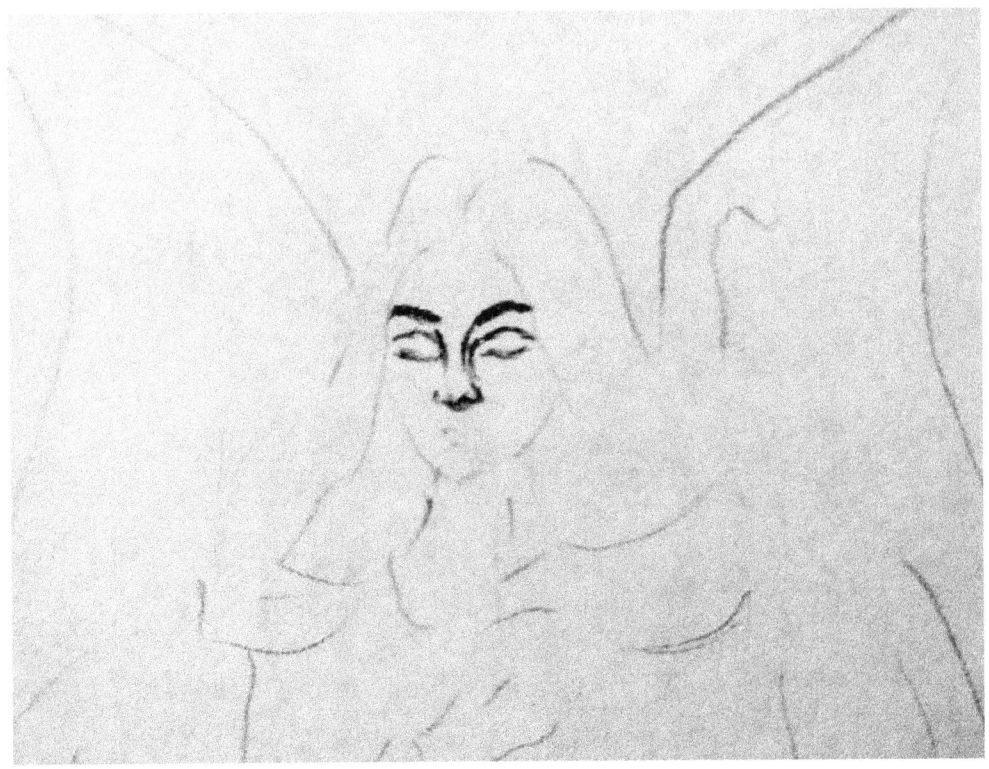

First, draw the basic outline of the witch, specifically the wings, the hair and the clothes. Next we're going to darken some of the features of her face – the eyebrows, the eyes, and the nose.

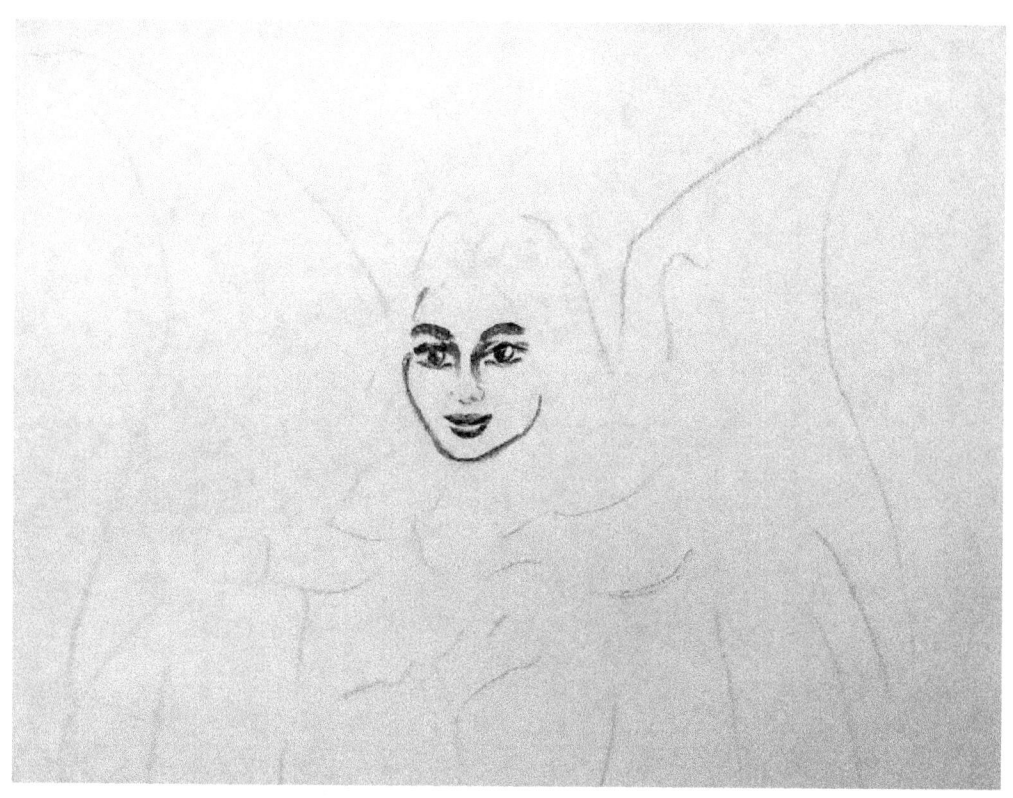

Darken the line of her jaw, and begin adding details to the face. Shading can make her lips look big and full, while also giving her eyes a bit of a shine.

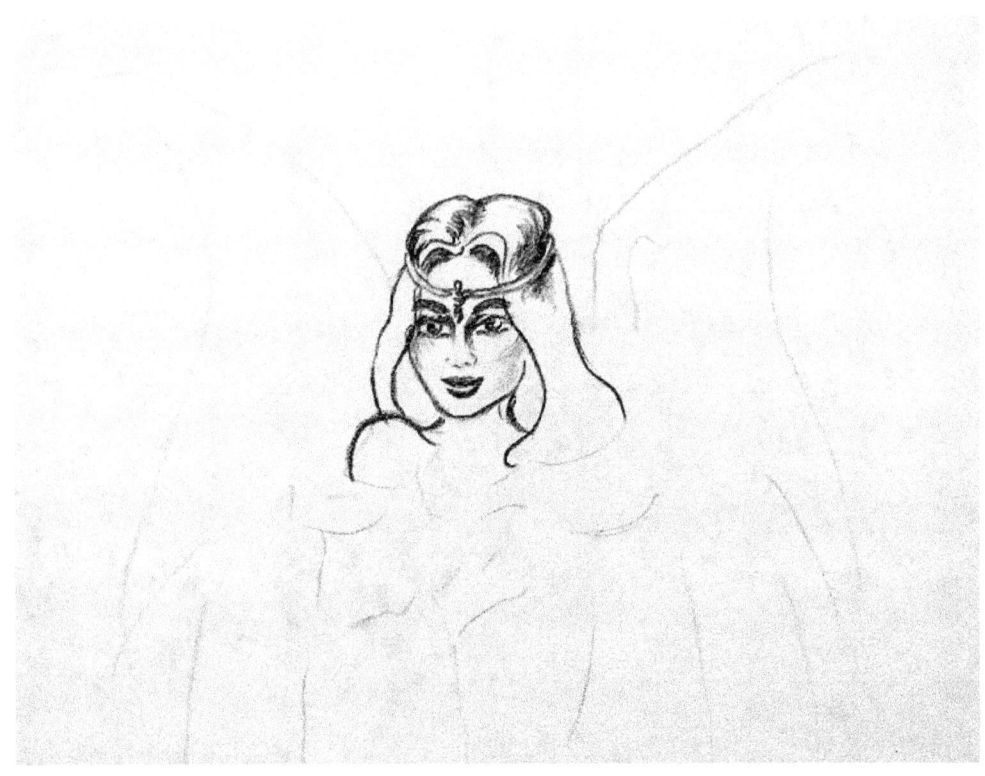

Next, we're going to outline her hair, her circlet, and the curve of her shoulder. Start to shade the hair and the cheeks a little, giving the impression of high cheekbones and wavy hair.

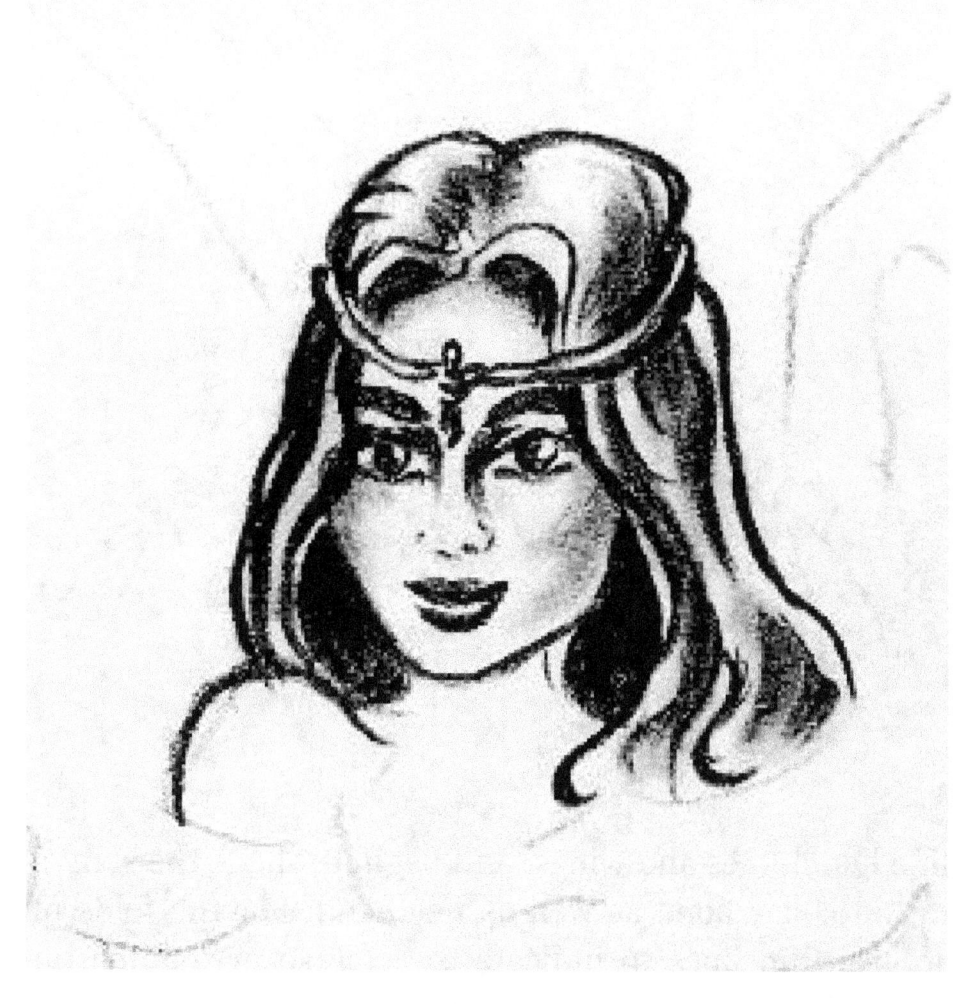

Finish shading the hair using sweeping strokes and the flat of your pencil.

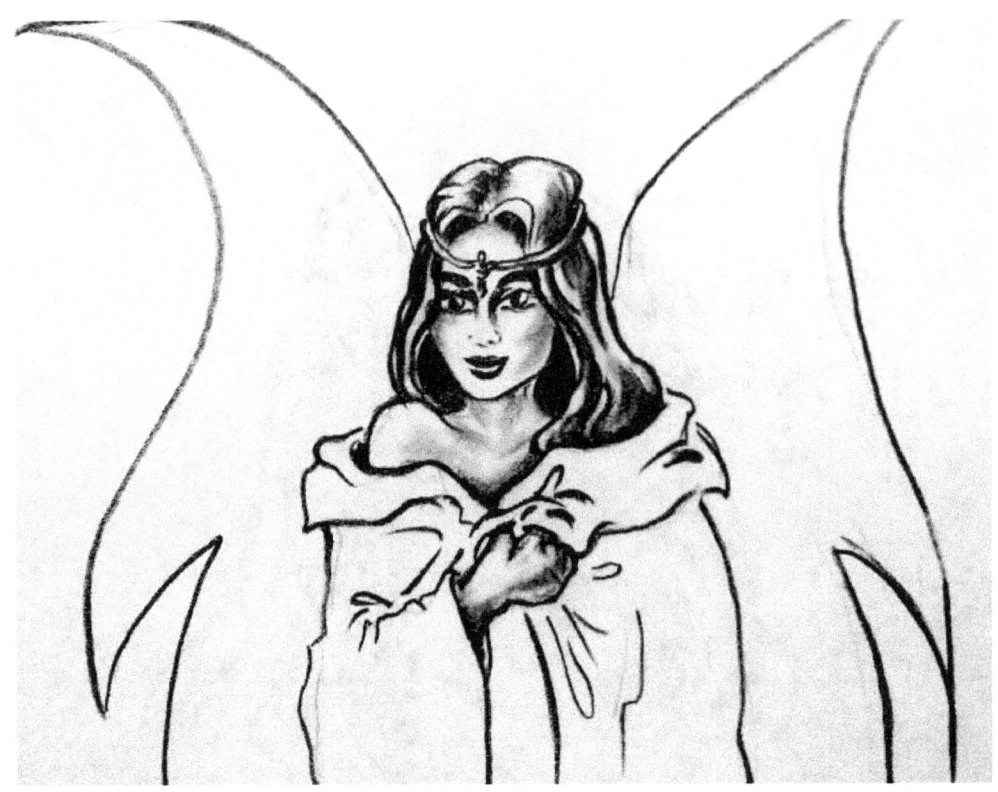

Outline her clothes and wings, and begin to shade the skin of her chest and collar bone as well as her hand. For the folds of the fabric, use thin lines to indicate the change in shading on the fabric itself. For the shading of the skin, use your finger or a smudge stick to create a little bit of a dusting over everything, giving it a smooth look.

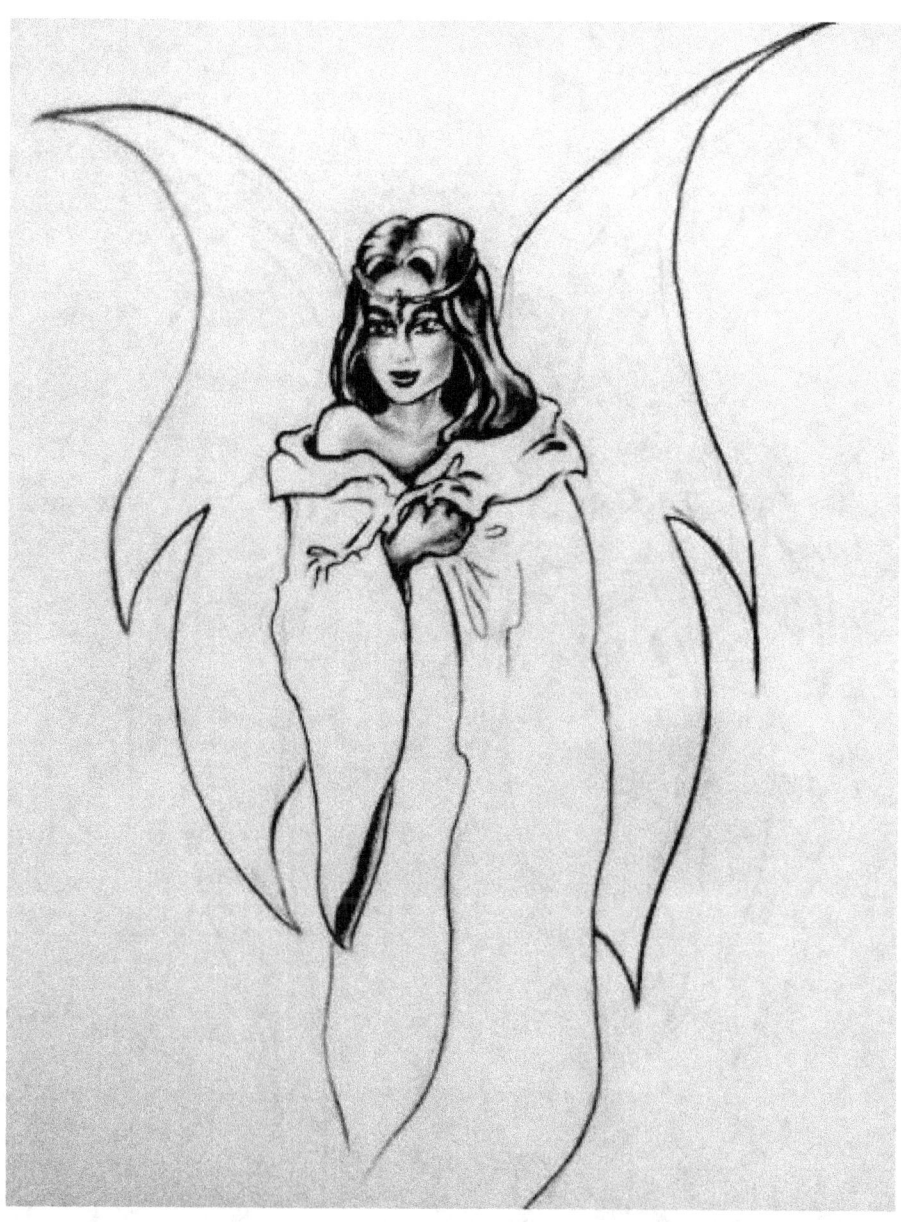

Continue outlining, making sure your lines are big and bold. For the shade of the inside of her sleeve, go ahead and fill that in with darkness and pressure – we want to indicate a bit of mystery, as well as showing that this is a deep shadow.

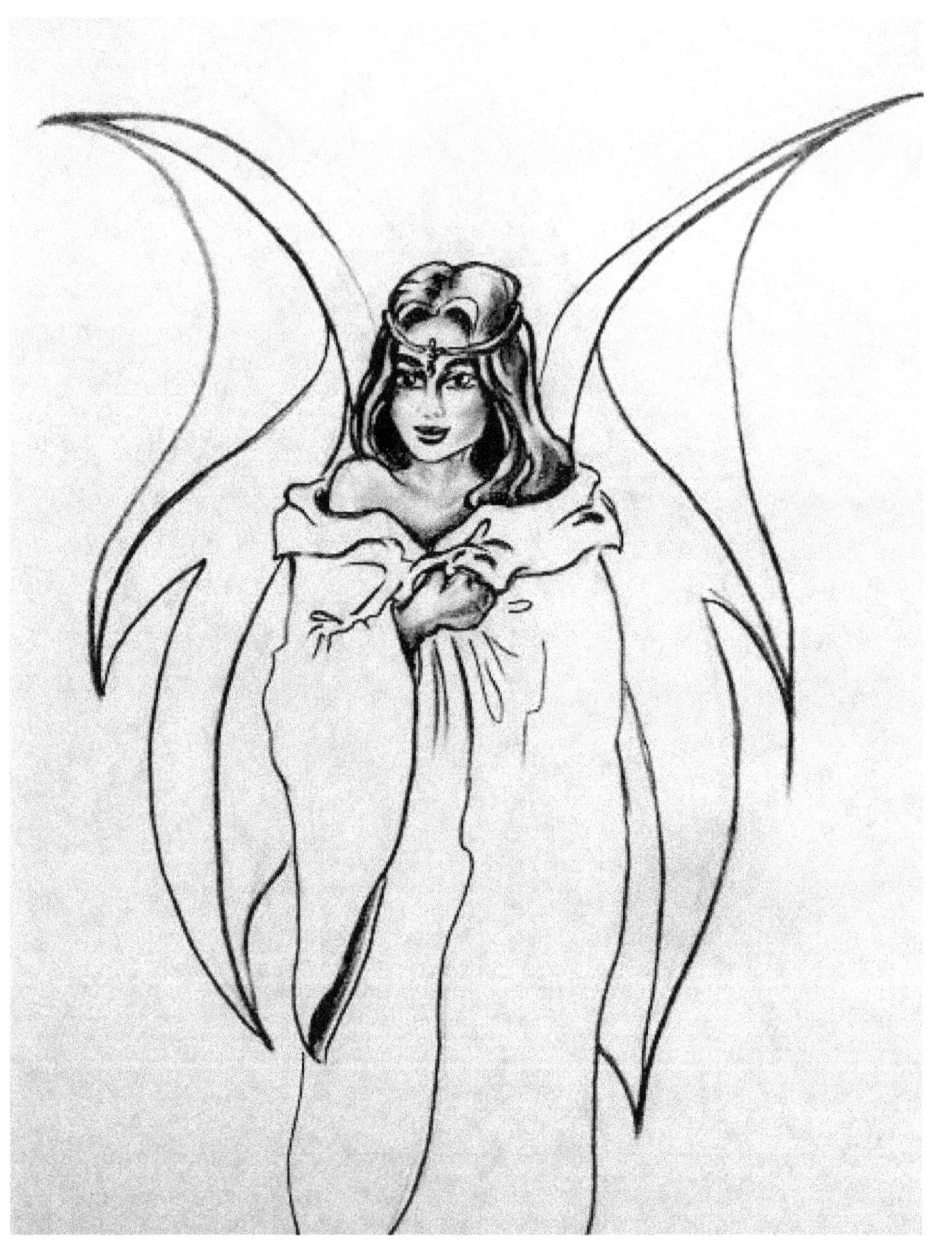

Begin to give detail to the wings, using steady curving lines.

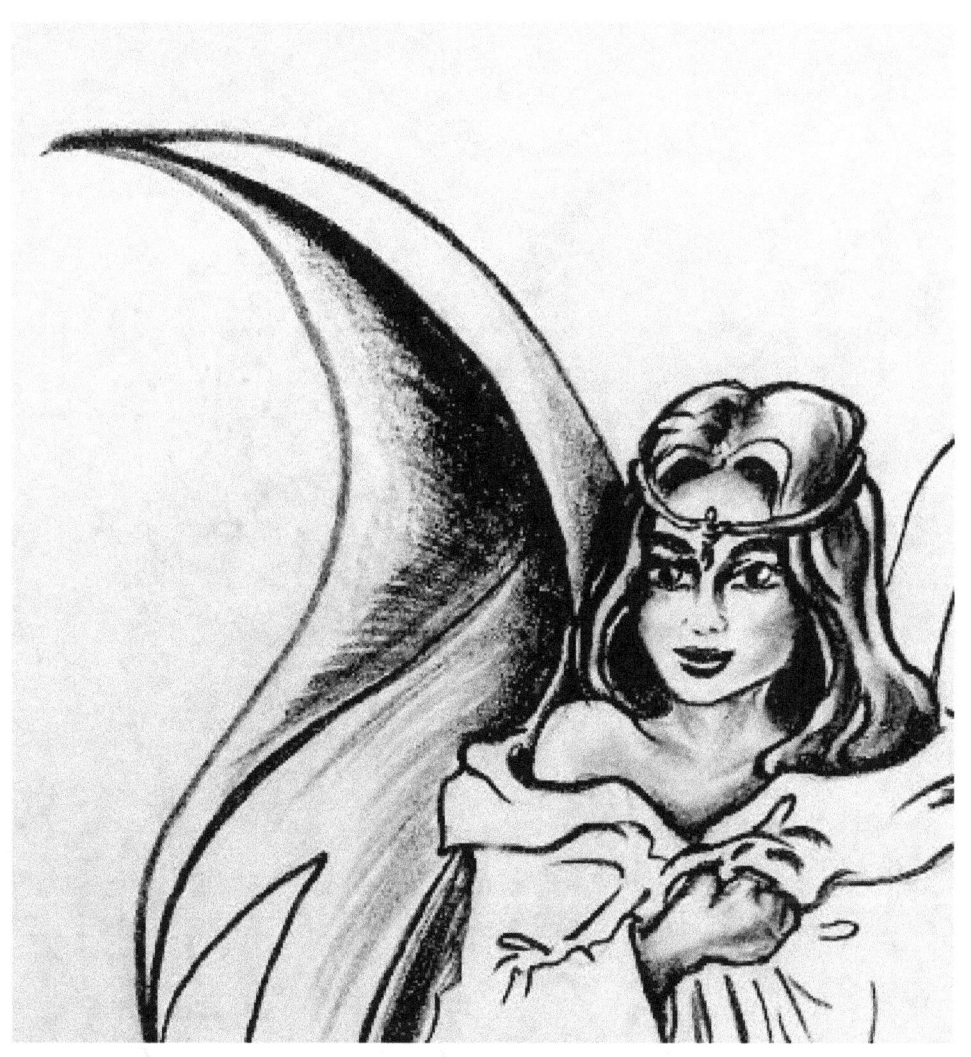

Then begin to add the shading of the wings. We want to give these a leathery look, so consider using a form of cross-hatching – or intersecting lines – to create the kind of shade that we need. Don't be afraid of darkness or pressure here.

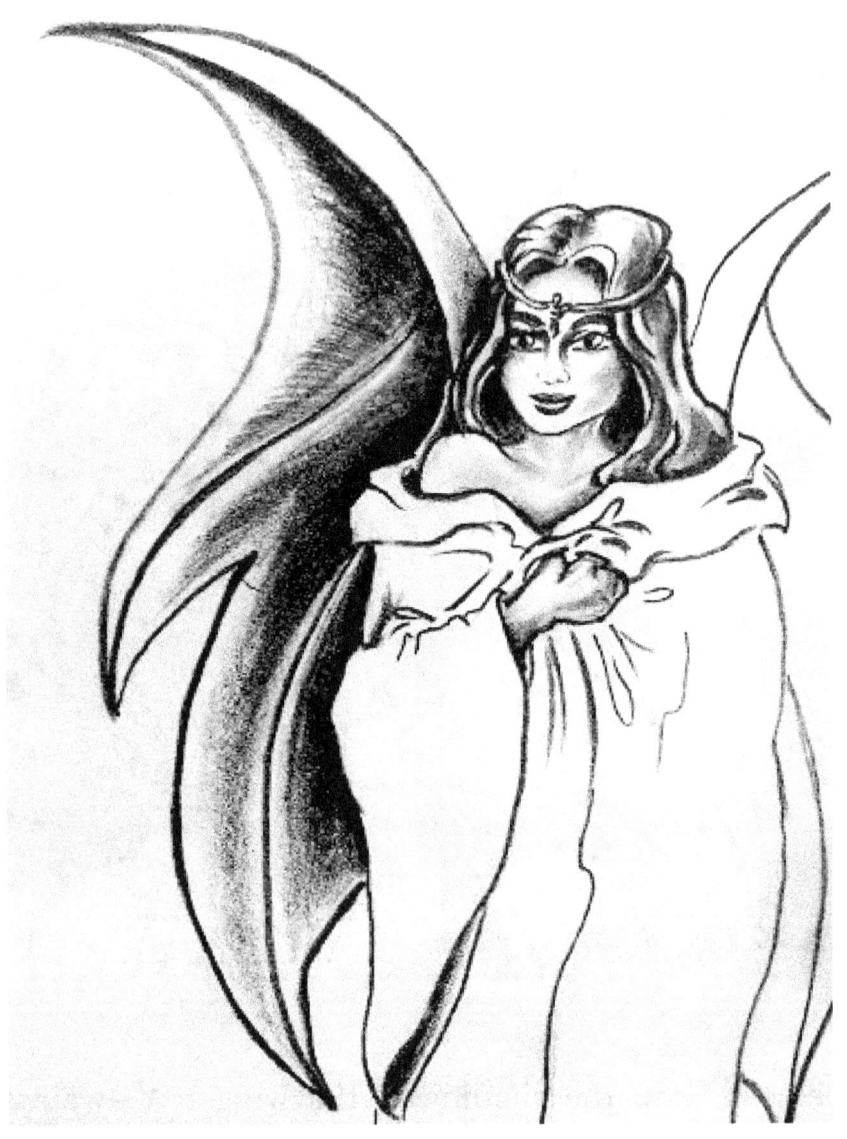

To finish the wing, smudge out towards the bottom or use the flat of your pencil to create smudge-like lines.

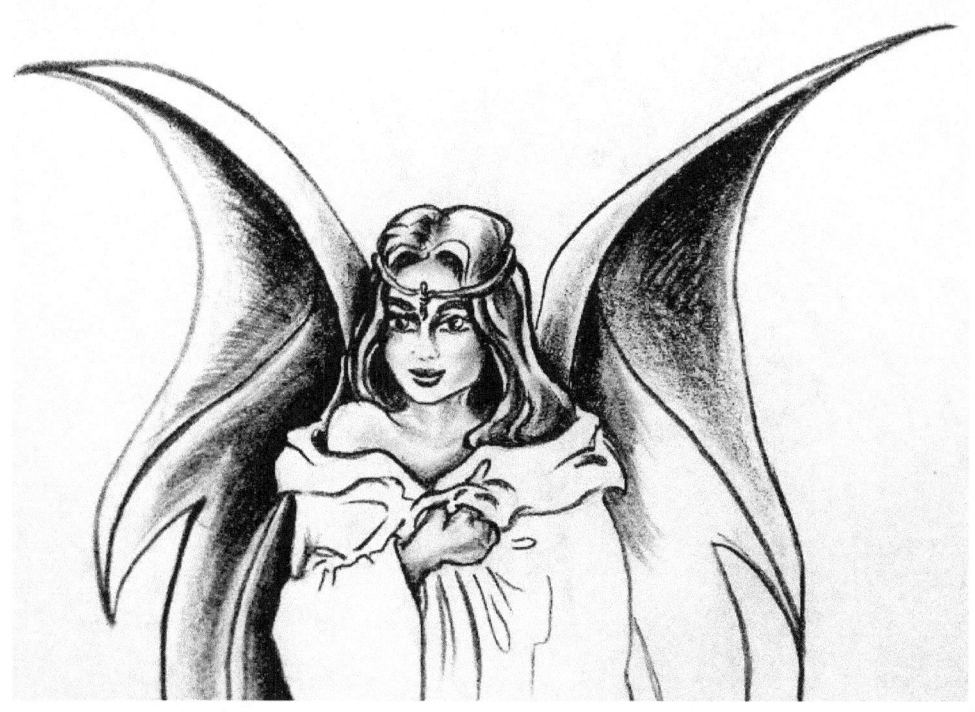

Start work on the other wing, considering what you've learned with the first one with cross-hatching and smudging.

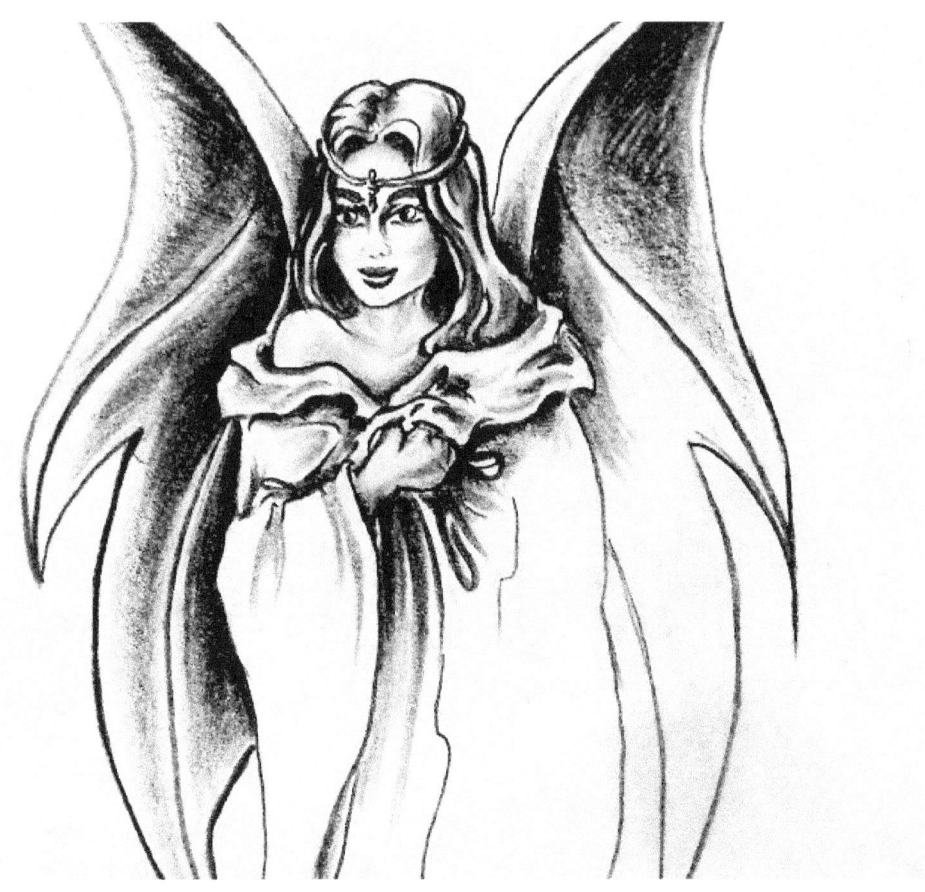

Take a moment to drift over to the clothing and give some shading there as well – light to indicate that the fabric is of a light color, but dark where she clutches it together.

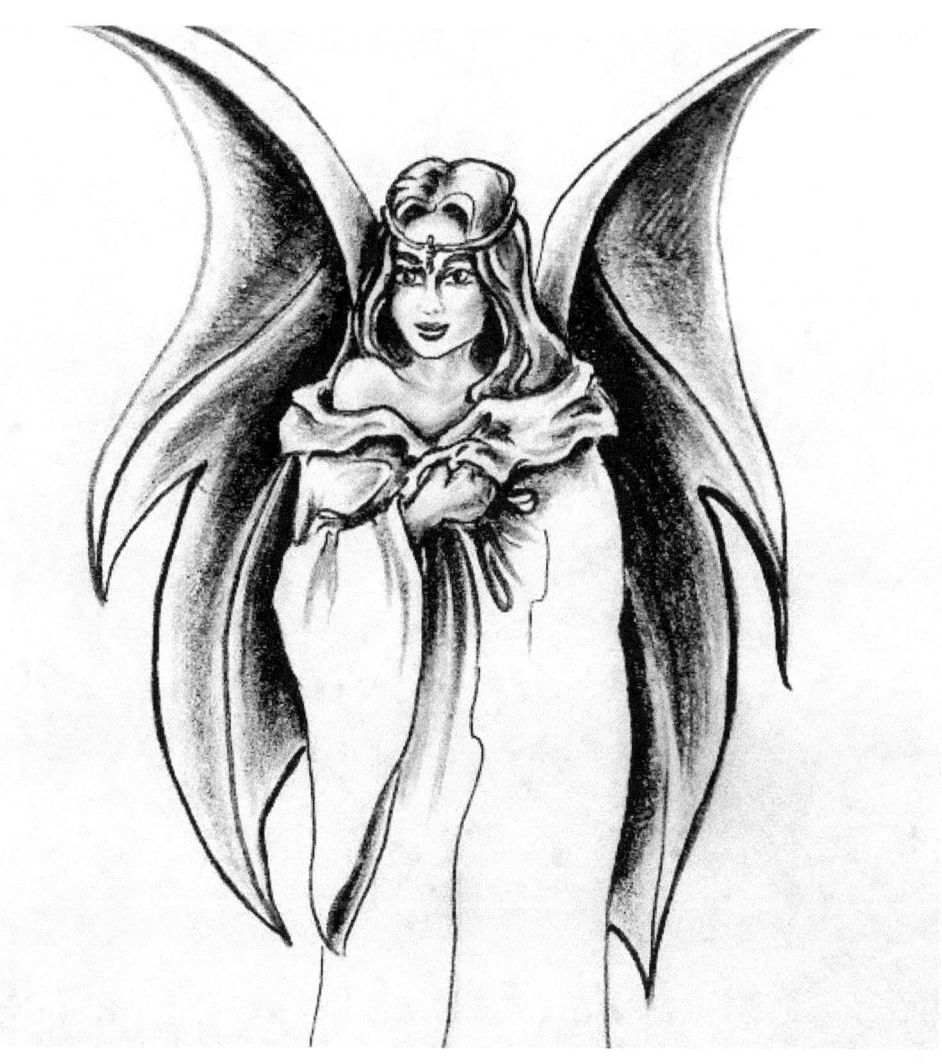

Finish up the wings with the smudging technique or the flat of the pencil.

Again using the flat of the pencil, give the bottom of the cloak some broad shading to represent big movements of fabric and grand folds. Pressure is your friend here – the harder you press, the darker the shadow.

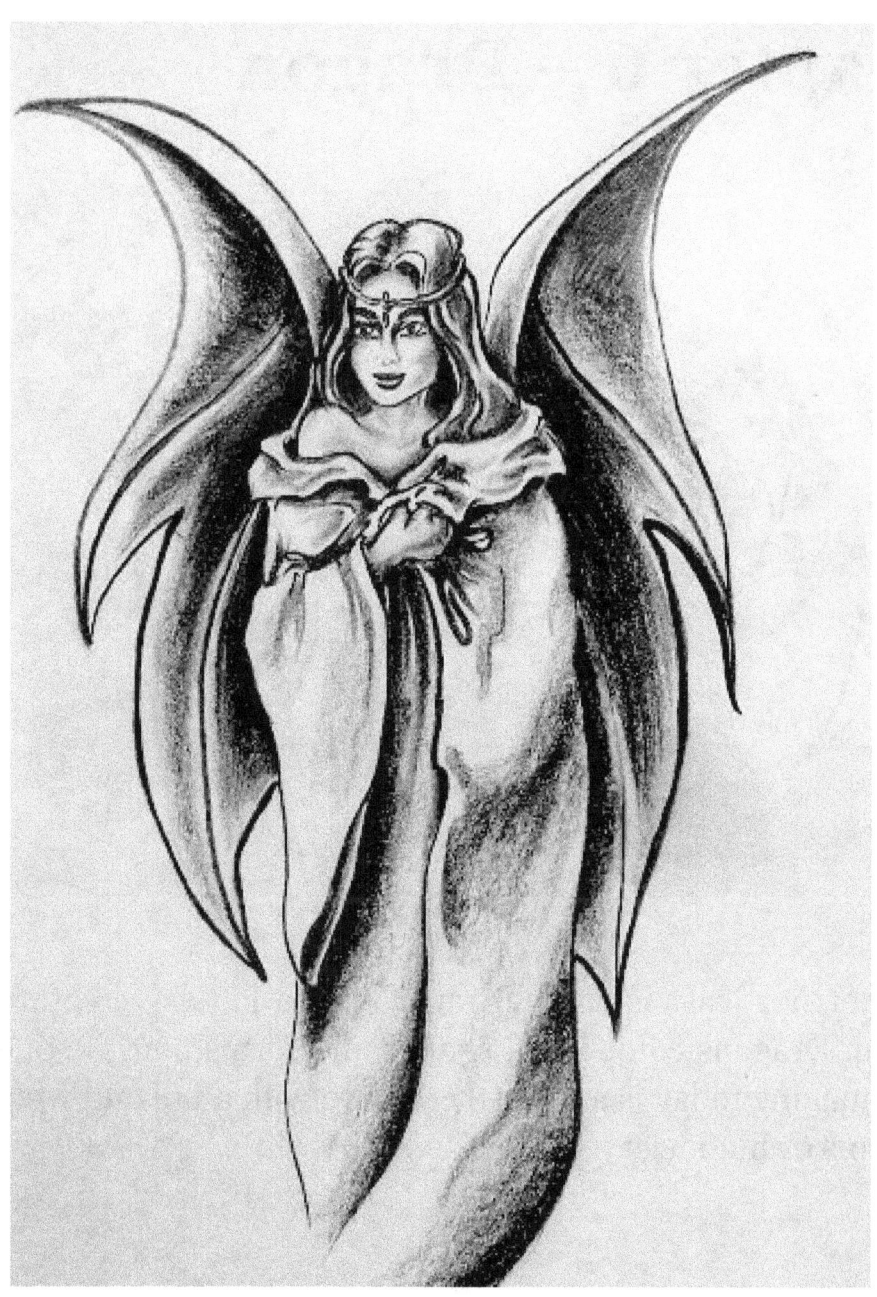

There you have a finished witch, ready to start casting spells and causing mayhem throughout your fantasy setting!

Chapter 6 – Dragon

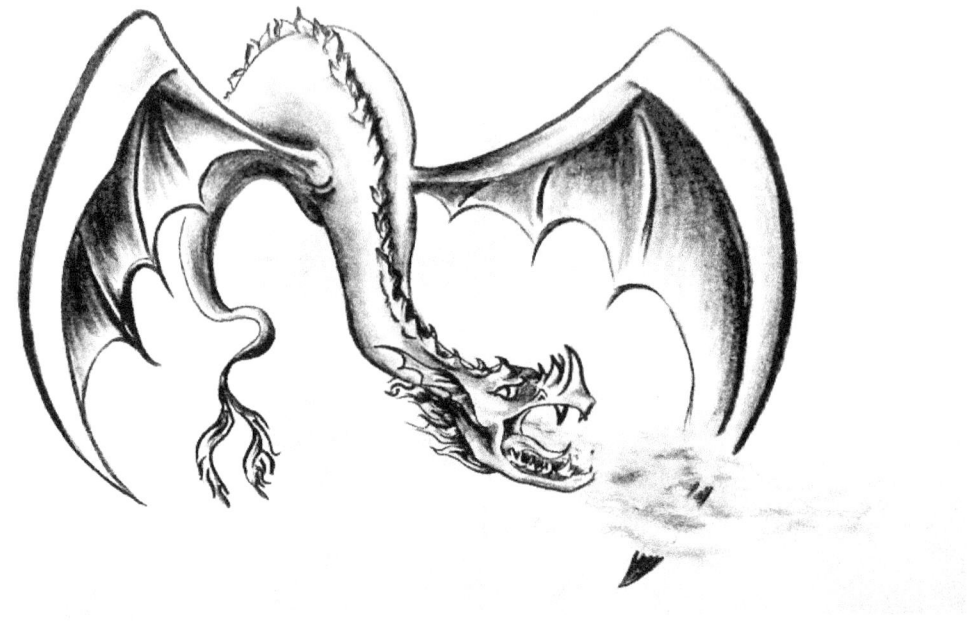

Last but not least is the all-time favorite fantasy creature, the dragon. Dragons come in all shapes and forms, but the one that we're making today is a winged creature with a tail and wings, no forearms or hind legs.

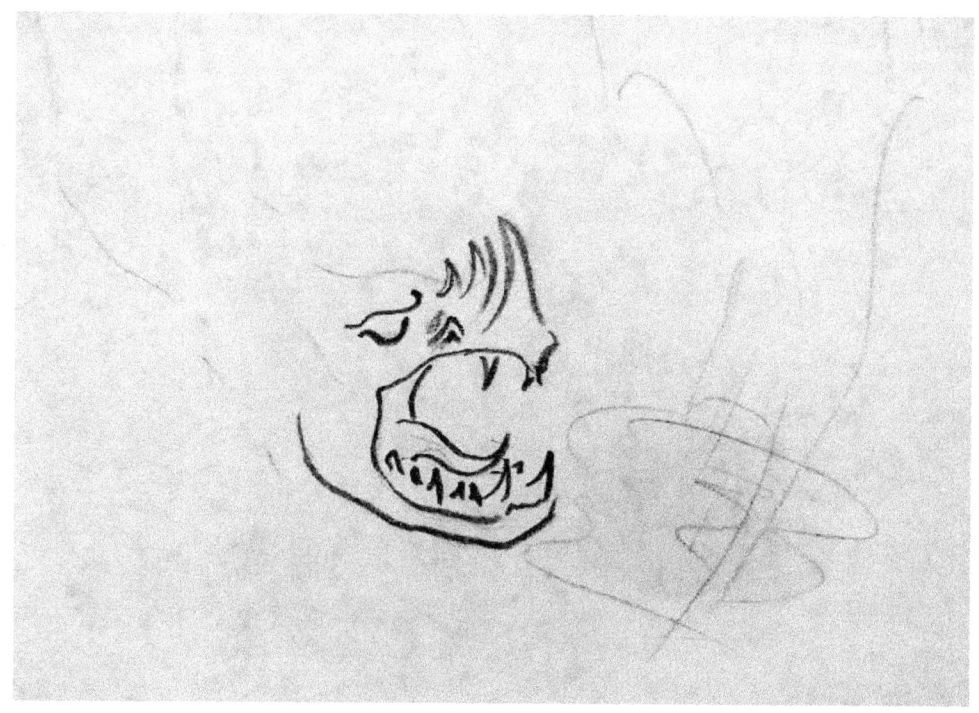

Start by drawing the basic outline for the dragon, including the smoke. Then, go back and darken the lines of the snout and jaw – we want our dragon to be snarling as though he's burning down an unsuspecting city. Add some detail of the teeth and nostril.

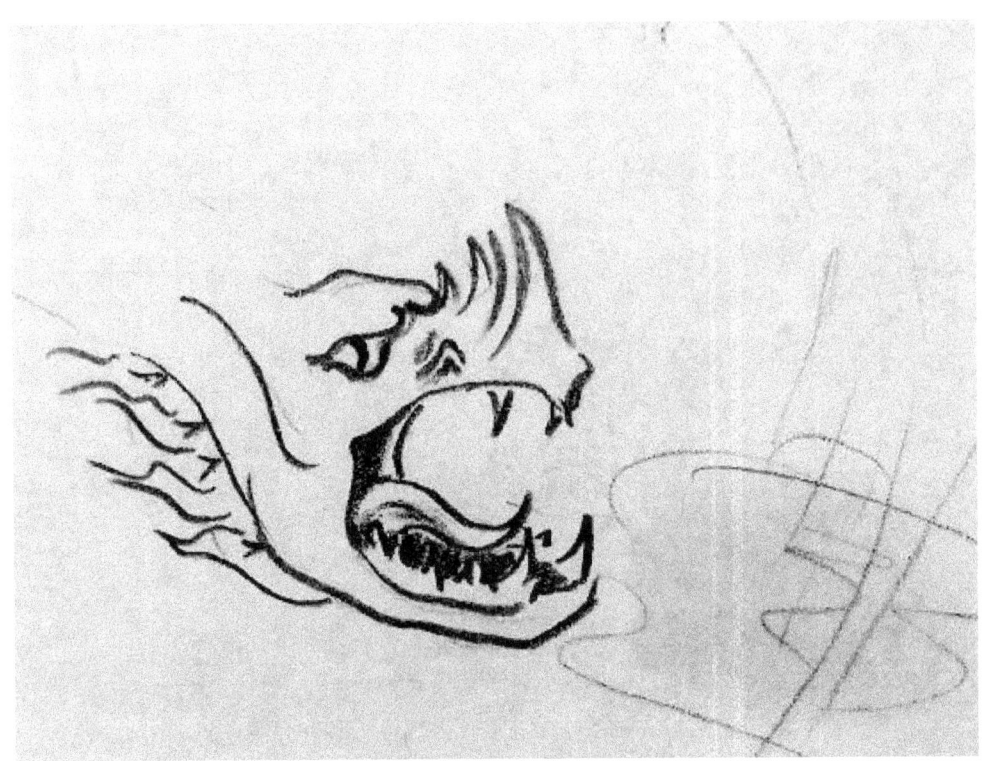

Next, add a little more detail – the shading in the mouth, the eye, the curve of the cheekbone and the beginning of the dragon's beard.

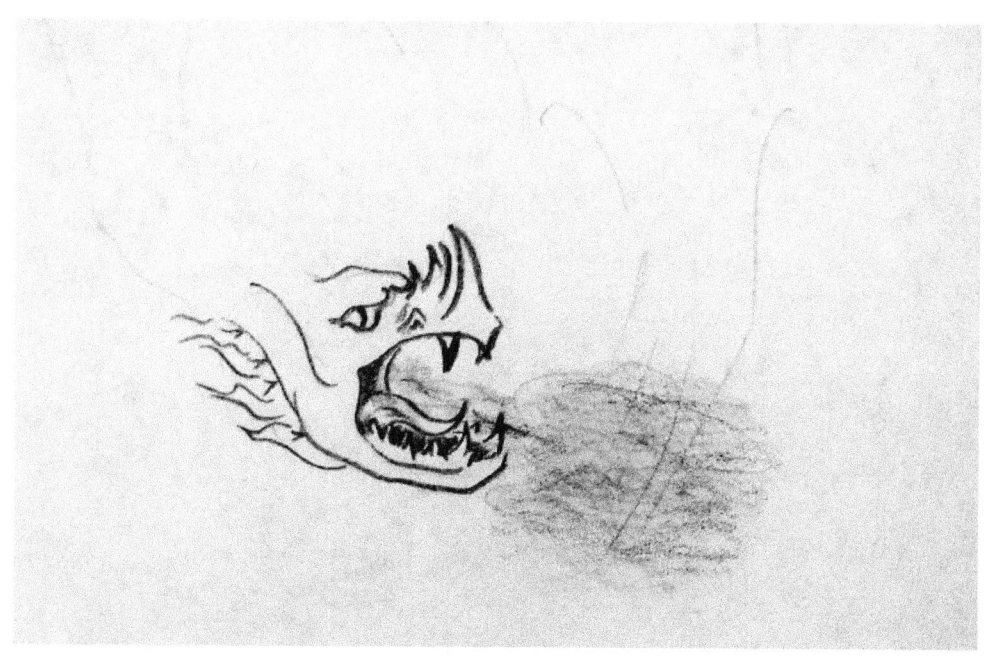

To get the fuzzy look of the smoke, use the flat of your pencil and then smudge it just a little.

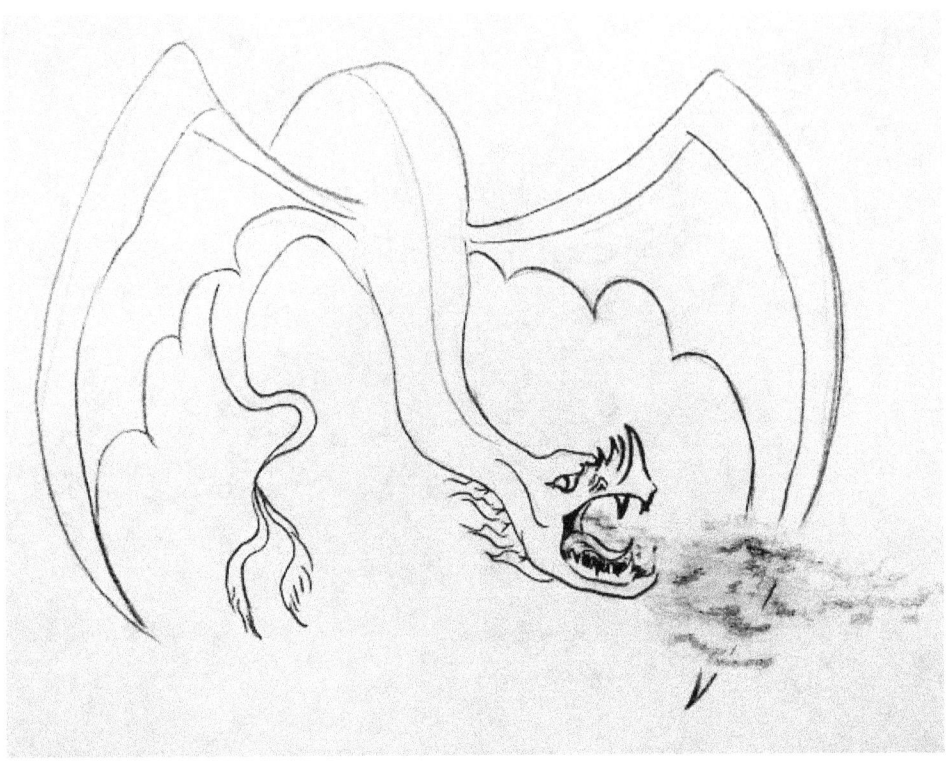

Now we're going to outline the rest of the dragon, making sure that the lines are dark.

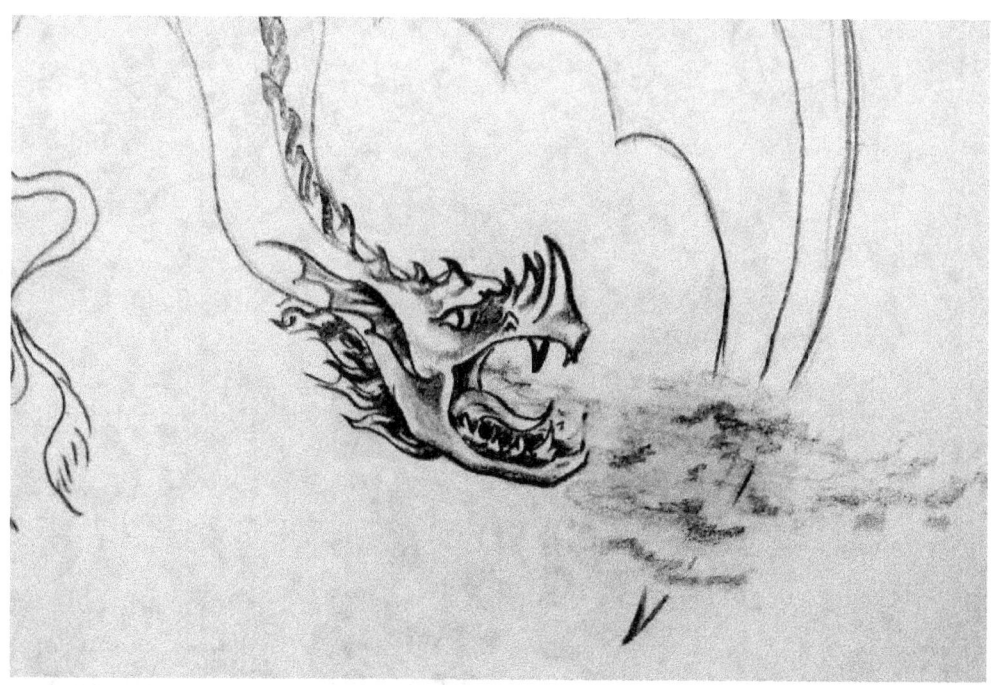

Start adding in some of the shading to the face. Remember, dragons have a hard exterior, so we don't really want it to flow – we want blocks of shading smudged to make shades of grey.

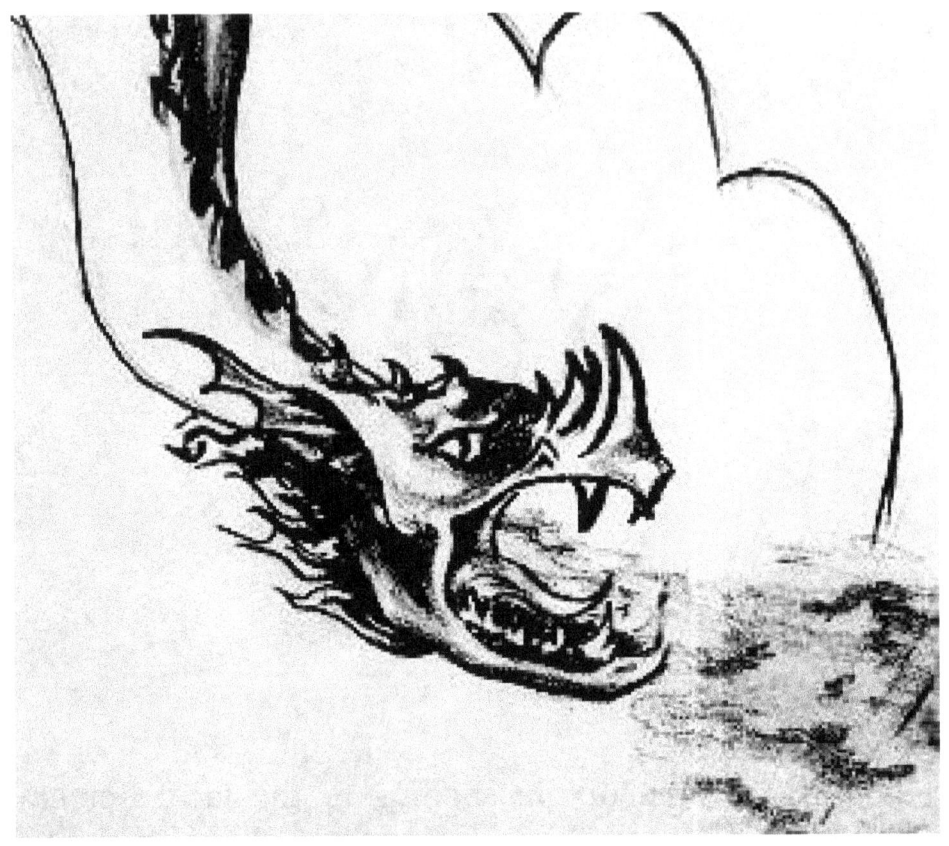

Shade the side of the dragon with the flat of your pencil to create broad shadows.

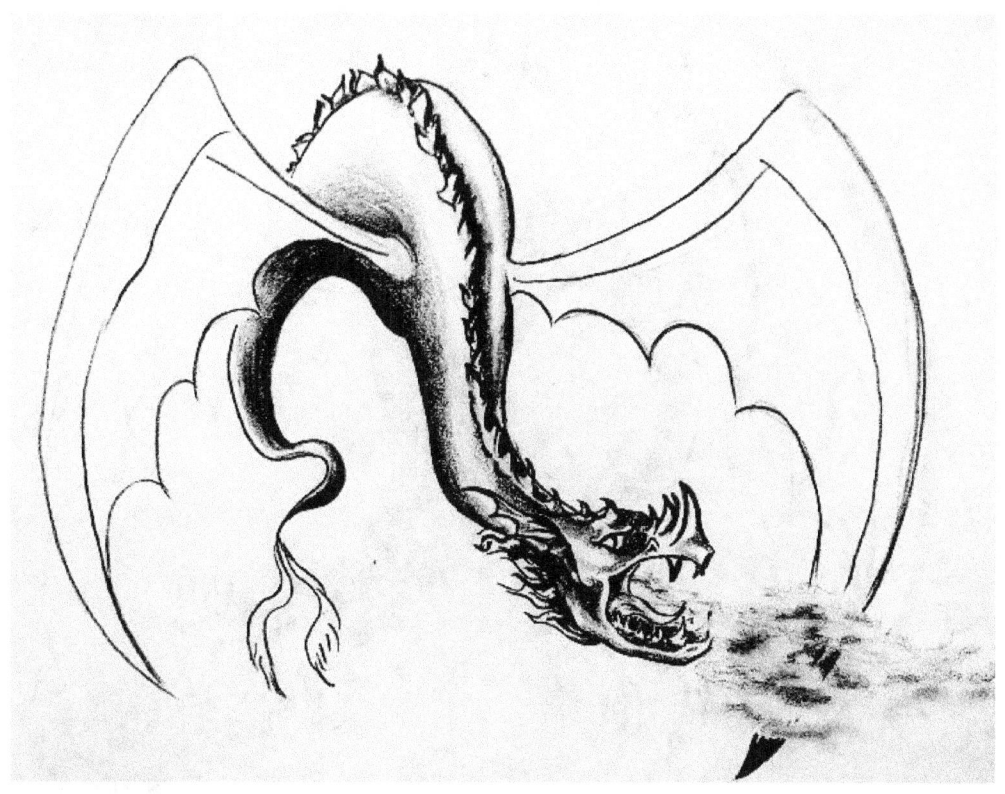

Now shade the other side of the dragon. The closer it gets to the underbelly, the darker the shadow will be. Also, remember to keep your shading smooth, keep the gradient going. You don't want to jump from dark to light suddenly, you want a progression of shades of grey.

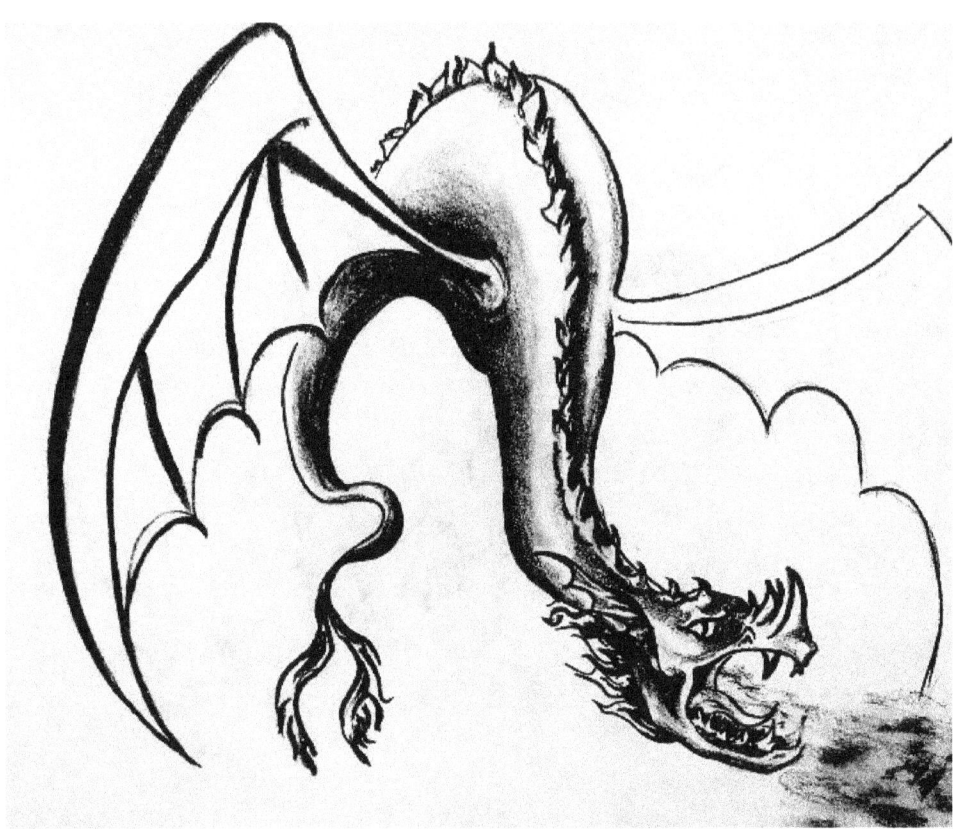

Give the wing broad, dark strokes to really make the edges stand out. Shade the tail carefully, and make it dark as the tail is below the dragon's belly.

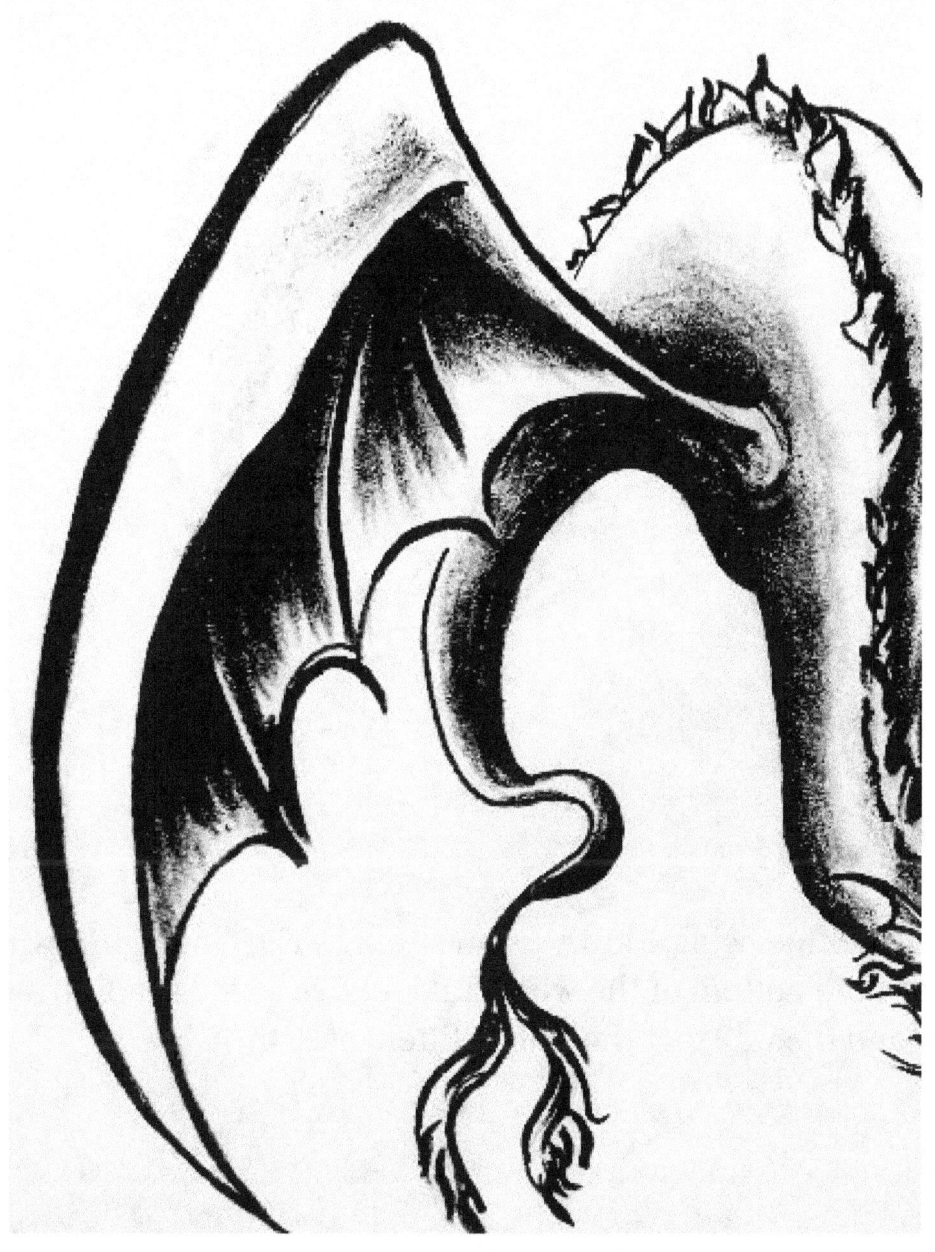

For the wing, use dark, sweeping strokes. Smudge it a little bit to give it an overall smoothed look, and don't be afraid of pressure here. Darkness is our friend when it comes to this wing.

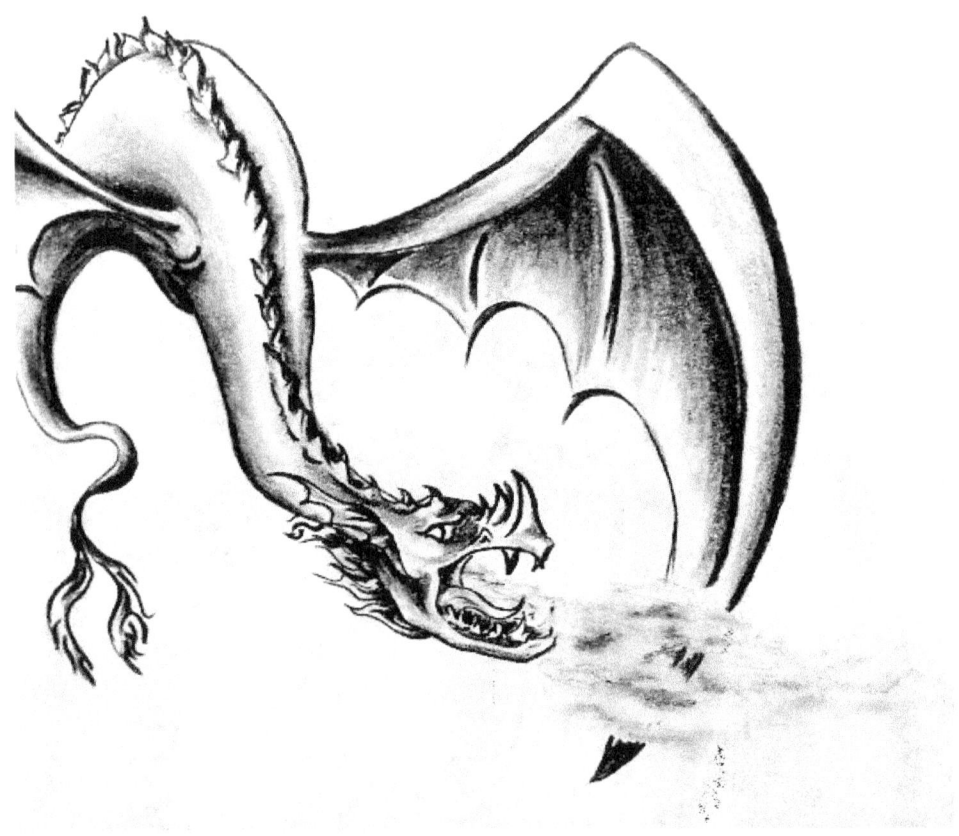

For the other wing, do the same thing. The highlights will be toward the bottom of the wing. Take notice of the shading on the edge and the way that the smoke filters over the wing.

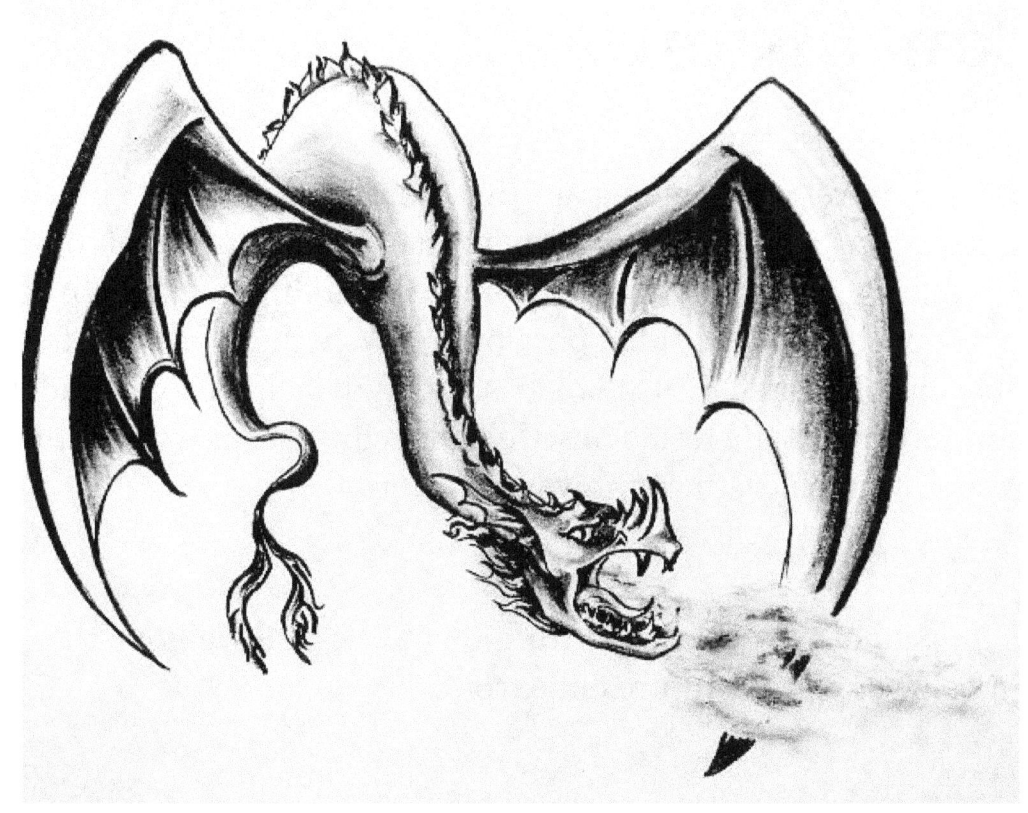

There you have a finished dragon, ready to kidnap princesses, burn down villages, and attack castles at your whim.

Conclusion

Drawing is relaxing, giving us time to think and contemplate while we concentrate on lines, pressure, shading, and other mechanics. Fantasy art can be a fun and fulfilling niche of art to learn, opening up a world of possibilities. Whether you draw for a hobby or for a career, this book has hopefully helped you broaden your horizons in the terms of style and technique, or, even better, inspired you to design your own characters.

We hope that you've learned from this book, and we hope that it can help you in your future endeavors!

Thank you!

Thank you for choosing our book, we hope you found it interesting and helpful.

If you liked the book, please give us a favor to write your review.

We would really appreciate this!

If you would like to have a bonus – **FREE BOOK**, please send the screenshot of your review to this e-mail: **kelly.artbooks@gmail.com** and we will send you a **FREE BOOK** in PDF as a **GIFT!****

Hope to see you in our future books and good luck in your drawing experience!

**** in the e-mail subject please mention the name of the book you reviewed and the author.**

www.ingramcontent.com/pod-product-compliance
Lightning Source LLC
Chambersburg PA
CBHW081206180526
45170CB00006B/2231